Art Alphabets, Monograms & Lettering

J. M. BERGLING

Foreword by
JAMES GURNEY

DOVER PUBLICATIONS, INC.
Mineola, New York

Bibliographical Note

This Dover edition, first published in 2019, is an unabridged republication of *Art Alphabets and Lettering* (fourth edition) and selections from *Art Monograms and Lettering* (tenth edition), originally printed by J. M. Bergling, Chicago, in 1923 and 1920. A new foreword by James Gurney has been specially written for this volume.

Library of Congress Cataloging-in-Publication Data

Names: Bergling, J. M. (John Mauritz), 1866–1933, author. | Gurney, James, 1958– writer of foreword. | Container of (work): Bergling, J. M. (John Mauritz), 1866–1933. Art alphabets and lettering. | Container of (work): Bergling, J. M. (John Mauritz), 1866–1933. Art monograms and lettering. Selections.
Title: Art alphabets, monograms, and lettering / J.M. Bergling ; foreword by James Gurney.
Description: Mineola, New York : Dover Publications, Inc., 2019. | "This Dover edition, first published in 2019, is an unabridged republication of Art Alphabets and Lettering (fourth edition) and selections from Art Monograms and Lettering (tenth edition), originally printed by J. M. Bergling, Chicago, in 1923 and 1920."
Identifiers: LCCN 2018042965| ISBN 9780486831701 | ISBN 0486831701
Subjects: LCSH: Alphabets. | Monograms. | Lettering.
Classification: LCC NK3640 .B435 2019 | DDC 745.6/1—dc23
LC record available at https://lccn.loc.gov/2018042965

Manufactured in the United States by LSC Communications
83170103 2020
www.doverpublications.com

FOREWORD

From the perspective of our era of computer-generated typography, it is difficult to appreciate the ubiquity of handmade lettering a century ago. Writing made by hand appeared not only in personal letters and postcards, but also in business correspondence, architects' plans, store windows, roadside billboards, theater lobbies, newspaper advertisements, college diplomas, engraved silverware, and even embroidered handkerchiefs.

At the dawn of the twentieth century, the art of hand lettering reached flamboyant, exuberant heights. The period known as the "Golden Age of Ornamental Penmanship" was still in full flower when John Mauritz Bergling (1866–1933) first published *Art Alphabets and Lettering* in 1914. He expanded his "encyclopedia of lettering" through three subsequent editions, culminating in an enlarged fourth edition of 1923. *Art Alphabets, Monograms & Lettering* is an exclusive volume from Dover Publications that combines the 1923 edition with specially selected pieces from *Art Monograms and Lettering* (tenth edition, 1920).

Art Alphabets and Lettering is one of the most sought-after of the many treasuries of designs and alphabets from that period, not only because of the high standards of Bergling's examples, but also because of the wide range of practical applications that he addressed.

In Bergling's day, the field of artistic writing spanned the work of many specialists: engravers, engrossers, architects, show card writers, and commercial artists. He took care to consider the appropriate spirit for each kind of communication, ranging all the way from a sober commemoration of a retirement from an insurance company (page 42) to a playful poster for a college dance (page 60).

Bergling was an authority in all these disciplines. As a boy, he emigrated with his father from Sweden, working in San Jose, California, and Chicago, Illinois,

FOREWORD

where he built his reputation as an engraver for watch cases and jewelry. He became one of the foremost practitioners of the art of the monogram, a popular graphic form where an individual's three initials are woven together into a clever artistic design. He produced three other design collections: *Art Monograms and Lettering*, *Ornamental Designs and Illustrations*, and *Heraldic Designs and Engravings*.

Art Alphabets and Lettering is Bergling's crowning achievement, culling the best specimens from his many years as a leading engraver and pen artist. To make room for more samples, Bergling eliminated the introductory text typically found in comparable books, such as *Ames' Compendium of Practical and Ornamental Penmanship* by Daniel T. Ames (1883) and *Studies in Pen Art* by William E. Dennis (1914). In such guidebooks, the text would have explained the theory and practice behind the alphabets. The modern reader might want to know at least the basics of the practical knowledge that Bergling took for granted.

For everyday penmanship, the steel dip pen had largely replaced the quill pen, which was made from a prepared primary flight feather of a goose or turkey. However, the quill pen was—and still is—the preferred tool for certain kinds of elegant writing and was the primary instrument for letterers before the nineteenth century. Steel pen nibs in Bergling's day were available in a range of degrees of flexibility, and many of them are still available today. The nibs fitted into a pen holder and were dipped into an inkwell of India ink, which was waterproof, or a water-soluble ink such as Higgins Eternal.

The collection begins with script alphabets, notable for their flowing connected letters, such as American Round-hand and Spencerian on pages 2 and 3. These models provide excellent guides for handwriting applications where a graceful elegance is required. The Spencerian alphabet was invented by Platt Rogers Spencer (1800–1864). It became standard in the United States between 1850 and 1925, after which it was replaced by the simpler Palmer method that was taught in schools up until recently.

Businesspersons were expected to convey their integrity and confidence by means of pen skills, culminating in a confident flourished signature. To achieve this kind of writing, penmanship instructors stressed the

FOREWORD

importance of good posture. First, the pen artist must take the proper position, seated in a straight chair with both feet flat on the floor, the back held straight. The pen is held, not in the tight grip of most beginners, but in a relaxed manner, the arm with its large muscle below the elbow resting lightly on the table.

"Whole arm" or "off hand" capitals, with their elaborate looping flourishes, are made without penciling the letterforms in advance. Their flowing grace requires a great deal of practice. They are written with broad movements of the arm, swinging easily from the shoulder. Fingers, wrist, and arm cooperate to create fluid movements. Each part of the flourish uses a smooth continuous stroke. By contrast, small letters should be rhythmically created with controlled finger movements.

Ideally, these scripts should be executed on a smooth cotton rag paper over lightly ruled guidelines drawn with a hard pencil. The slant of the letters should be absolutely uniform. The slant can be ruled lightly with an adjustable triangle set to a fixed slope and resting on a T-square or parallel rule. Most scripts require a slant of between fifty-two and fifty-four degrees from horizontal, or the three-quarter angle diagrammed on page 32. An oblique pen holder angles the nib to the right, allowing a better wrist position.

In settings where script writing needs to be larger and more precisely considered, it can be constructed by drawing the letters first in outline and then filling them in with a brush or pen, as shown on pages 30 and 31. In general, it is a good idea for the student to begin constructing letters larger and at a slow speed. With improving skill, the execution typically becomes smaller in scale and more rapid. It is advisable to try for accuracy and quality first and then for speed.

The pen-based script alphabets, with their German and French variants, derive from the models produced by engravers in the eighteenth century, requiring the artist to incise a series of fine lines into a copperplate with a sharpened steel tool called a "burin." The position of the tip of the burin is shown in the drawings on page 32. This copperplate engraver's alphabet also can be constructed with the flexible steel pen nib. Each weighted or shaded stroke

FOREWORD

broadens on the pulling downstroke. Whichever tool is used, this thick-and-thin copperplate style is slow to execute, making it more suitable for headings and superscriptions than for everyday handwriting.

Bergling includes broad pen alphabets familiar to modern calligraphers such as "Black-Stone" (page 20), "Mixed Roman Text" (page 86), and the single-stroke Roman and Italic alphabets (page 88). Informal round-tipped alphabets such as those on page 87 can be achieved with a Speedball "Style B" pen nib.

The Roman alphabets shown on pages 14, 72, 73, and 74 are the oldest and most universal in this collection. The Italian Renaissance capitals on page 72, which in turn derive from those carved into Trajan's Column in Rome, deserve careful study because they are the basis for many subsequent variations. Note the circular outside shapes of the *C*, *G*, *O*, and *Q*; the narrowness of the *S*; the nearly midline crossbars on the *E*, *F*, and *H*; and the serifs (the small spurs or feet at the top and bottom of ascenders). Achieving the nuances of classic Roman capitals is difficult with single stroke construction using a lettering brush or a broad pen, but the example on page 85 shows an attractive alphabet that can be constructed rapidly with a broad pen or flat-tipped brush.

Most traditional alphabets have a consistent distribution of thick and thin lines. Typically, letterforms are drawn with greater thickness on the vertical ascender, compared to the horizontal crossbar, a byproduct of pen technique. Novel effects can be achieved by using a constant thickness throughout the letter (pages 65, 69, 70, 76, 87, 91) or by reversing the normal relationship of thick and thin lines (pages 59, 68, 90).

Being "modern" or "artistic" or "up-to-date" became an obsession in Bergling's day. He revels in eccentric departures from the staid rhythms of traditional alphabets. He includes Art Nouveau features, such as curving ascenders (pages 54, 66, 67), curlicue serifs (pages 50, 69, 76), or crossbars placed high or low (pages 50, 51, 55, 56, 58, 64, 65). Thanks to his experience weaving letterforms into monograms, Bergling was especially adept at interlocking ascenders and descenders (pages 24, 25, 59, 60, 61). Some of these ideas were revived by underground comic artists in the 1960s,

FOREWORD

such as R. Crumb, who took a strong interest in both the music and the phonograph sleeve design of Bergling's era.

Printing technology was rapidly changing at the threshold of the twentieth century. Photoengraving and photolithography allowed lettering to be printed directly from the original pen work. This opened up a range of possible effects and liberated graphic design from the relatively labored and mechanical look of set type and hand engraving. The photomechanical processes also made reproduction possible at a size smaller than the original.

These technological changes encouraged the growth of extravagant drawing-based alphabets, such as "Rustic" (page 26) and "Leaf Cipher-Letters" (pages 22, 24). Highly embellished initial capitals can be hand-drawn with a pen or brush, using inks of various colors or tinted shades. Some of the ornamental initial alphabets are presented with a variety of stylistic treatments, such as "Ornamented French Script" (page 16) and "Ornamental Initials" (page 94).

"Old English" (page 33) remains the standard for formal settings, such as diplomas, but it is difficult to execute well, especially if speed is required. It succeeds best with a steady rhythm and even spacing, using a square cut nib. Sometimes good results can be achieved by executing all the vertical strokes first, followed by the diamond shaped feet. A pointed pen adds the finishing touches, sharpening the corners and serifs and completing the hairline strokes on the capitals and on the lower case *a* and *r*. Examples with and without retouching appear on page 34.

Two other forms of artistic writing, less familiar today, are "engrossing" and "show card" writing. Engrossing was a particularly lavish type of decorative lettering used on resolutions, certificates, testimonials, memorials, and manifestos. The examples shown are by Patrick W. Costello (1866–1935), whose engrossing work was notable for being executed in limited tones of Payne's gray or umber. Originals were as large as twenty-two–by–twenty-eight inches, often illustrated with flags, portraits, flowers, or other pictorial devices. They reflect a culture that placed a premium on congratulatory or memorializing messages, usually presented publicly to formally recognize individual achievements.

FOREWORD

Bergling invited his colleague William H. Gordon to demonstrate show card writing, a more casual advertising form (pages 82–91). Painted signboards of the nineteenth century tended to use only uppercase letters, but they were gradually replaced by signs made with both uppercase and lowercase. The letters in Gordon's alphabets are formed quickly and without much preliminary drawing, using specialized brushes with opaque water-based media. Practitioners in this field were called "writers" rather than "letterers." Whether employing the brush or the pen, the student should start by thoroughly understanding the construction before attempting too much speed.

By the time Bergling's books appeared, typewriters already had been standardized and were coming into common use for business communications. Fountain pens and then ballpoint pens became established by the mid-twentieth century. The Golden Age of Ornamental Pen Work was disappearing. I hope that with the aid of this exclusive treasury of art from Dover Publications, a new generation of designers can rediscover artistic lettering and adapt it to contemporary uses.

James Gurney
March 2019

Art Alphabets, Monograms & Lettering

SELECTIONS OF MODERN DESIGNS

MONOGRAMS

AND

LETTERING

BY

J. M. Bergling

FOR THE USE OF

ENGRAVERS · ARTISTS · DESIGNERS

AND

ART WORKMEN

TENTH EDITION

Published by J. M. BERGLING

1254 Rosedale Ave. Chicago, U. S. A.

1920

Vol. 1

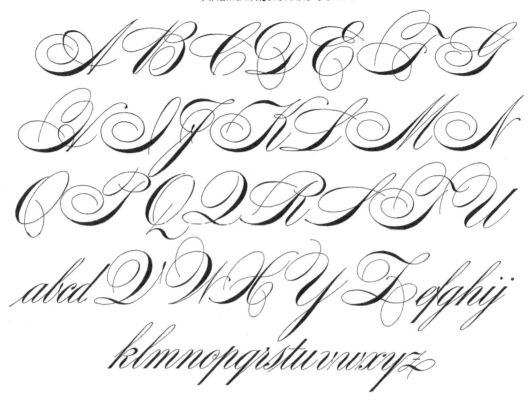

ABCDEFG
HIJKLMN
OPQRSTU
abcd VWXY Zefghij
klmnopqrstuvwxyz

MODERN FRENCH SCRIPT

ABCDEFG
HIJKLM
NOPQRST
UVWXYZ

Stationers Script

A B C D E F G H I
J K L M N O P Q R
S T U V W X Y Z

abcdefghijklmnopqrstuvwxyz &
1234567890

SPENCERIAN SCRIPT

A B C D E F G H I

abcdefghyk J K lmnopqrstu

L M N O P Q R S T

U V W vwxyz X Y Z

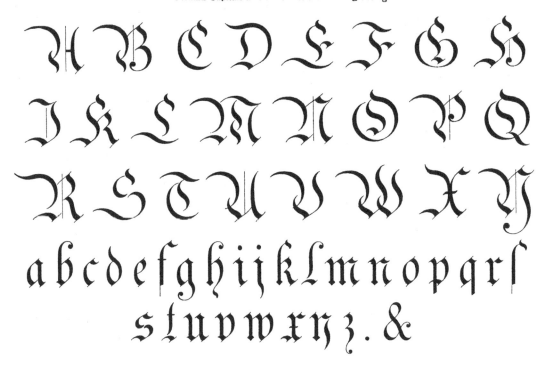

A B C D E F G H
I K L M N O P Q
R S T U V W X Y

a b c d e f g h i j k l m n o p q r s
s t u v w x y z . &

German Script.

A B C D E F G H I I
J K L M N O P Q R
S T U V W X Y Z U

a b c d e f g h i k l m n o p q r s t u v w x y z

French Ronde.

abcdef B Df H Rhkuout.

A B C D E F G H I K
L M N O P Q R S T U
1 2 3 4 5 V W X Y Z 6 7 8 9 0
abcdefghijklmnopqrstuvwxyz

La patience est la clef de la jouissance?

German Gothic

A B C D E F G H I K
L M N O P Q R S T U
a b c d V W X Y Z efghi
jklmnopqrsftuvwxyz.

5

ABCDEFGHIK
LMNOPQRSTU
WXYZ

MODERN GERMAN

ABCDEFGHIKLM
NOPQRSTUVWXYZ

abcdefghijklmnopqrstuvwxyz

UNCIAL GOTHIC INITIALS

ABCDEFGHIJK
OPQRSTULMN
DWXYZ MB

ABCDEFGHIJ
KLMNQPRSTU
abcde VWXYZ fghij
klmnopqrfstuvwxyz.

Romany & Americus.
Florence 1714 — 1914 Italy.

CINCINNATI. JB BARCELONA.

Italic Capitals and Small Letters

ABCDEFGHIJK
LMNOPQRSTU
abcd VWXYZ efghij
klmnopqrfstuvwxyz. &

Italien Alphabet a.d. XVI.

A B C D E F G H
J K L O P Q R
S T U V X Y.

abcdefghiklmnopqrſt
uvw Waldeck-Pyrmont. xyz.

Alphabet in japanese Form

A B C D E F G H I
J K L M N O P Q R
S T U V W X Y Z

abcdefghijklmnopqrstuv
wxyz. MB

Engrossing Script

ABCDEFGHI
KLMNOPQR
STUVWXYZ

abcdefghiklmnopqrstuvwxyz
1234567890.

MODIFIED CURSIVE

ABCDEFGHI
KLMNOPQRST
UVWXYZÆ MN

abcdefghijklmnopqrs
Paris ſtuvwxyz & Wien
London 1234567890 Berlin

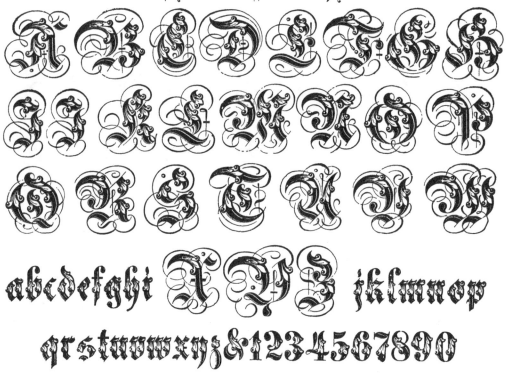

abcdefghi ILMZ jklmnop

qrstuvwxyz &1234567890

Deutsche Schrift XVII.Jahrh.

abcdefghiklmnopqrstuvxyz

A B C D E F G H I

K L M N O P Q R

S T U V W X Y Z

a b c d e f g h i k l m n o

p q r s t u v w x y z z.

1 2 3 4 5 6 7 8 9 0. 1 2 3 4 5 6 7 8 9 0.

A B C D E F G H I

K L M N O P Q R

S T U V W X Y Z

Copperplate Engravers Alphabets.

DÜRER 16th CENTURY GOTHIC

ABCDEFGHIKLMNOPQRSTU

abcdefghiklmnopqrstuvwxyz

 WXY

GERMAN GOTHIC

ABCDEFGHIKLMNO

PQRSTUVWXYZ

abcdefghiklmnopqrstuvwxyz

ENGLISH GOTHIC LETTERS 15th CENTURY.

ABCDEFGHIJKLMNOPQRS

TUVWXYZ. ENGLISH 14 Cent.

UNCIAL GOTHIC INITIALS

ABCDEFGHIJKLMNOPQ

RSTUVWXYZ 14th GERMAN

12

GREEK ALPHABET

CHARACTER	NAME		CHARACTER	NAME		CHARACTER	NAME	
A α	Αλφα	Alpha	I ι	Ἰῶτα	Iota	P ϛ ρ	P ω	Ro
B β ϐ	Βῆτα	Beta	K χ	Κάππα	Kappa	Σ ϭ ϛϛ	Σιγμα	Sigma
Γ γ ſ	Γάμμα	Gamma	Λ λ	Λάμβδα	Lambda	T ι η	Ταῦ	Tau
Δ δ	Δέλτα	Delta	M μ	Μῦ	Mû	Υ υ υ	Ὑψιλὸν	Upsilon
E ε	Ἐψιλὸν	Epsilon	N ν	Νῦ	Nû	Φ ϕρ	Φῖ	Phi
Z ϛϛ	Ζῆτα	Zeta	Ξ ξ	Ξῖ	Xi	X χ	Χῖ	Chi
H η	Ἦτα	Eta	O ο	Ὀμιχρὸν	Omicron	Ψ Υ ψ	Ψῖ	Psi
Θ ο ϑ	Θῆτα	Theta	Π ϖ π	Πῖ	Pi	Ω ω	Ὠμέγα	Omega

The Greek Alphabet, written

A, a B, b Γ, γ D, δϑ E, ε Ζ, z ϛ H, η Θ, ϑ
I, ι K, ϰ Λ, μ M, μ N, ν Ξ, ξ O, o Π, ϖ
P, ρ Σ, σς ΣΤ, τ V, ν Y, Ρ, φ X, χ Y, y Ω, ω

JMB

CELTIC

Ꝺꝺ B b C c Ꝺ ꝺ E e F f ꝿ ꝿ ꞑ ꞑ I ı

ꞁꞁ Ꝺꞃ m ꞃ N ꞃ O o P p Ꞃ ꞃ S ꞃ T ꞇ U u

HEBREW ALPHABET

Tau Sin Shin Resh Koph Tzade Final Tzade Pe Final Pe Gnain Samech Nun Final Nun Mem Final Mem Lamed Caph Final Caph Yod Teth Hheth Zain Vav He Daleth Gimel Beth Aleph

ת שׂ שׁ ר ק ץ צ ף פ ע ס ן נ ם מ ל ך כ י ט ח ז ו ה ד ג ב א

13

Modern Letters

ABCDEFGHIJKLM
NOPQRSTUVWXYZ

ABCDEFGHIKLM
NOPQRSTUVWXYZ

ROMAN ORNAMENTED

ABCDEFGHIJK
LMNOPQRSTUV
12345WXYZ67890

ABCDEFGHIKLMNOP
QRSTUVWXYZ

A B C D E F G H K L M N
O P Q R S T U V W X Y Z.

COMPREHENSIVE BENEFICENCE
Advanced Ideas and
Various Uses Suggested for this Beautiful Series

SPURRED ROMAN

ABCDEFGHIJKLMNO
PQRSTUVWXYZ&$,.:;
abcdefghijklmnopqrs
12345tuvwxyz67890

Heavy top and bottom Block

ABCDEFGHIJKLMNOPQRSTU
$12345 VWXYZ & 67890
abcdefghijklmnopqrstuvwxyz

Modern gothic Initials

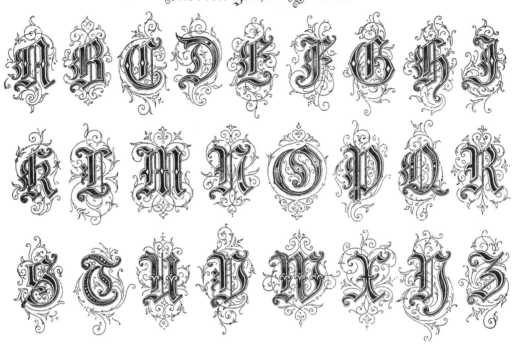

Ornamented French Script.

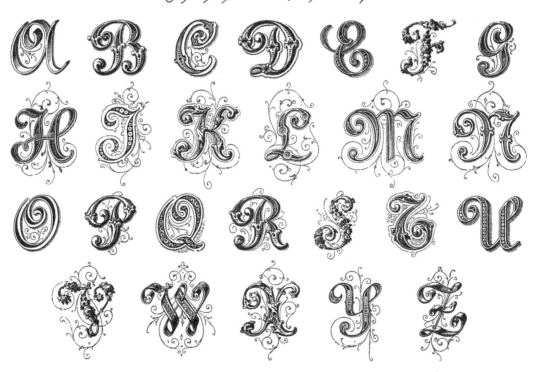

English Church Text.

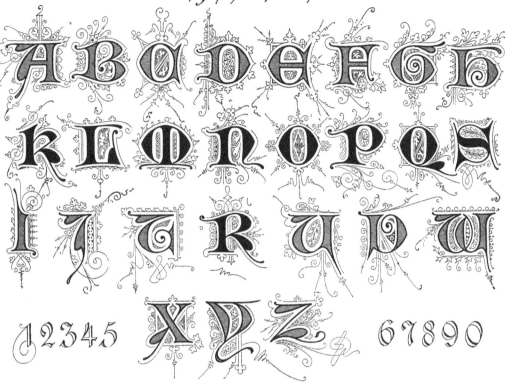

ABCDEFGH
KLMNOPQR
SITRUVW
12345 XYZ 67890

Gothic modified.

ABCDEFGHIK

LMNDPARS

ab CDWXYZU cd

efghiklmnopqrstuvwxyz

17

Art Craft Text

ABCDEFGHIJ
KLMNOPQRS
TUVWXYZ

When Knighthood was
in Flower

Lady Constance. Duke of York

Golden Anniversary Celebration
The English Tea Shop MB

Venetian Pearl

ABCDEFGHIJ

KLMNOPSRTU

VWXYZ. SPRAY

MODERN GOTHIC

A B C D E F G H I
J K L M N O P R
S T U V W X Y Z

By J M BERGLING

The Gothic Letters
From the Italian. 17 Century

A B C D E
F G H I K
L M N O P
Q R S T U
V W X Y Z

Ex Libris

Theo. P. Maison

Washington D.C.

In God We Trust

UNCIAL GOTHIC
14 Century

A B C D E
F G H I J
K L M N O
P Q R S T
U V W Y

Christmas Celebration

First Baptist Church
Of New York

December 24th.

19

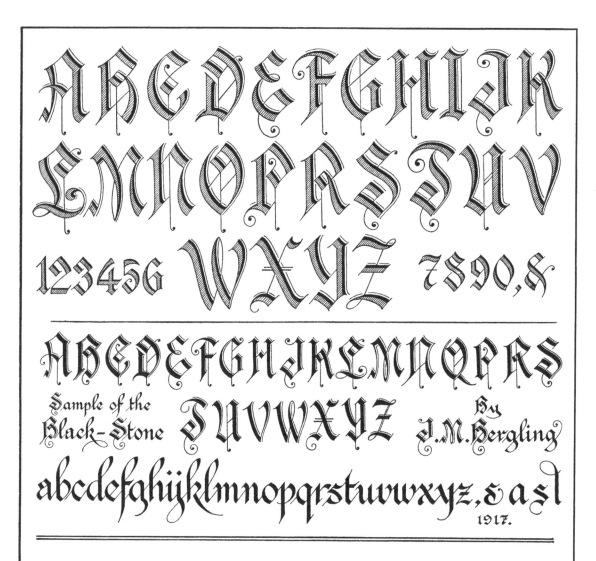

ABCDEFGHIJK
LMNOPRSSUV
123456 WXYZ 7890,&

ABCDEFGHIKLMNOPRS
Sample of the
Black-Stone TUVWXYZ By J.M.Bergling
abcdefghijklmnopqrstuvwxyz,& asl
1917.

THE SOCIETY GREEK
By J.M.BERGLING '17.

ABCDEFGHIJKLM
NOPRSTUVWXYZ
abcdefghijklmnopqrstuvwxyz,.
12345 Designed for Society Printing 67890

Modern Gothic (Old English),

ABCDEFG
HIJKLMN

Old English.
AMERICAN STANDARD

ABCDEFGHIJ
KLMNOPQRST
UVWXYZ JMB

OPQRST
UVWXYZ

21

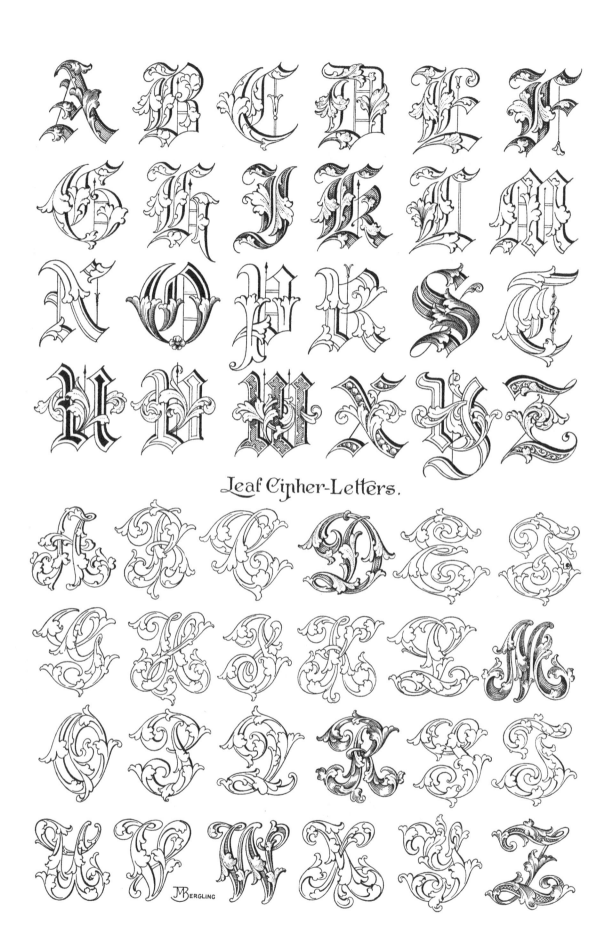

Leaf Cipher-Letters.

JM. BERGLING

22

New Style Fancy Initials

BY J.M.BERGLING

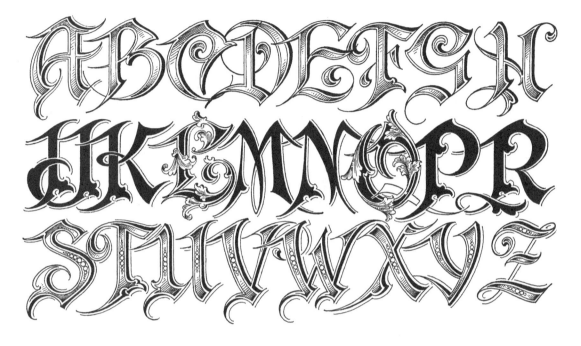

New Style Ribbon

BY J.M.BERGLING.

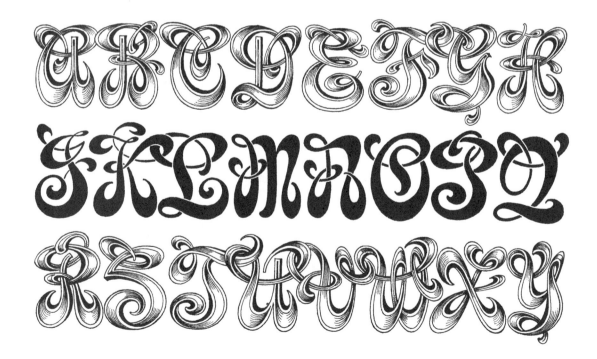

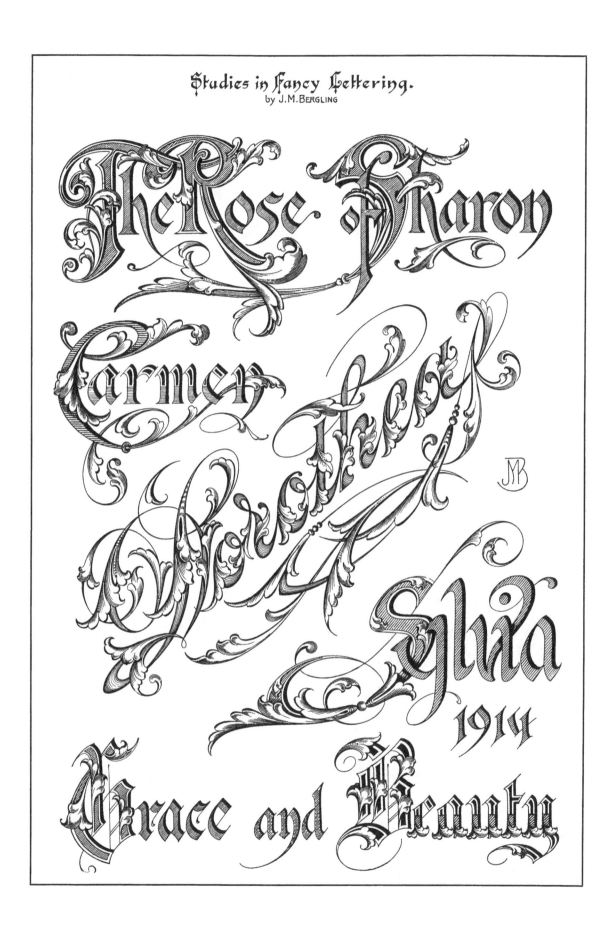

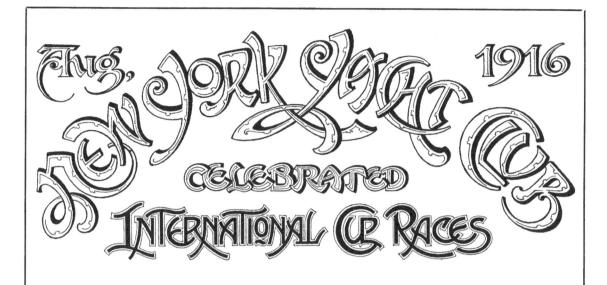

Aug., NEW YORK YACHT CLUB 1916
CELEBRATED
INTERNATIONAL CUP RACES

BOSTON COUNTRY CLUB
Robert E. Ward, Pres't.
Golf and Lawn Tennis

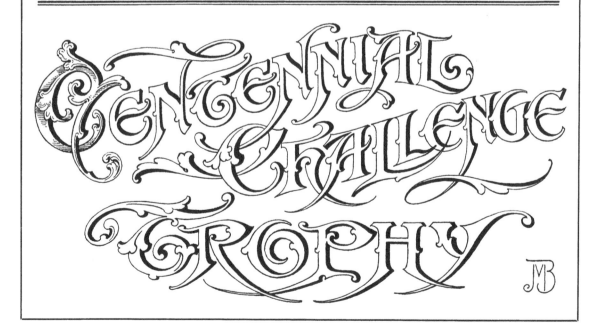

CENTENNIAL CHALLENGE TROPHY

RUSTIC ALPHABET.

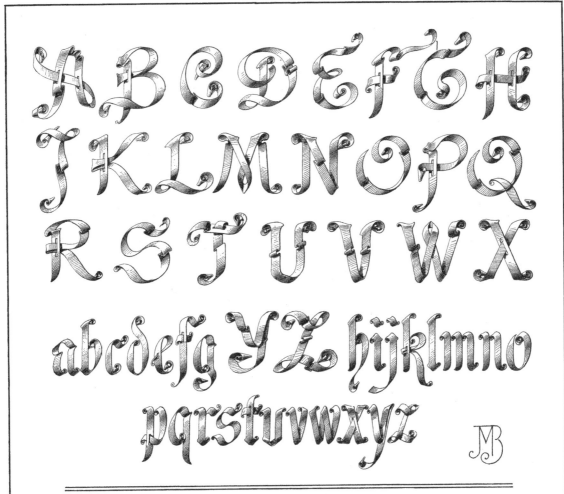

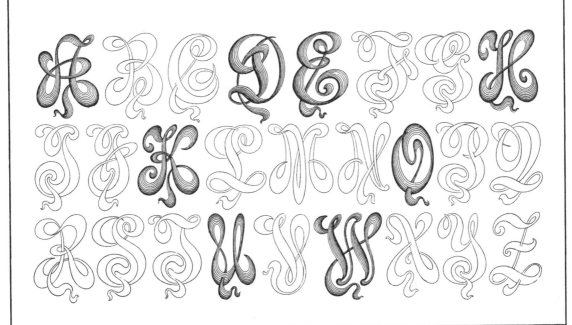

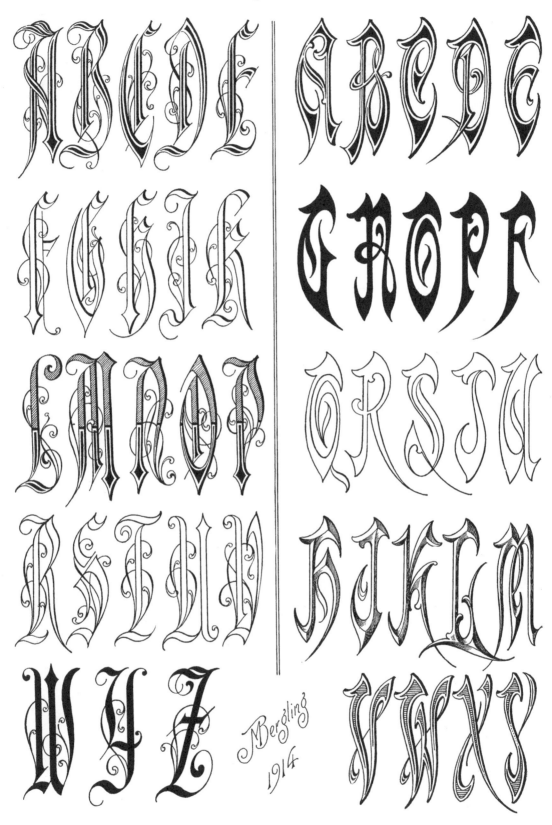

Bergling
1914

LA FRANCE

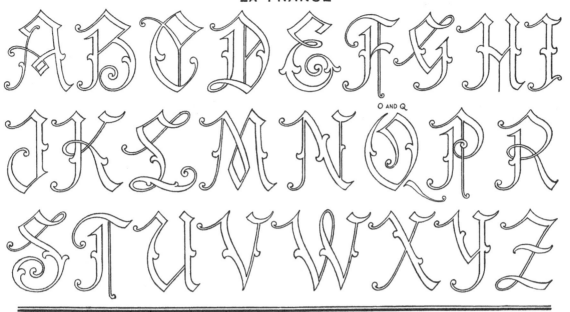

O AND Q

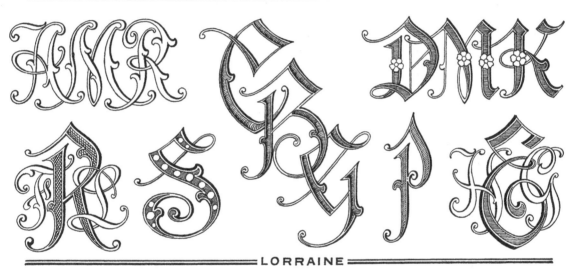

LORRAINE

abcdefghijk

lmnopqrstuv

wxyz Script

Mode of Construction

3123&

456789

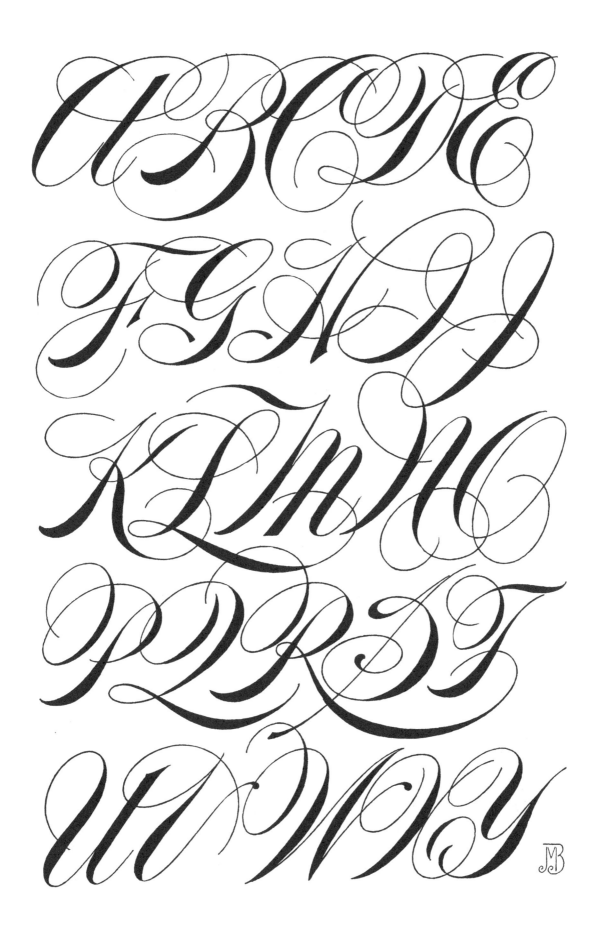

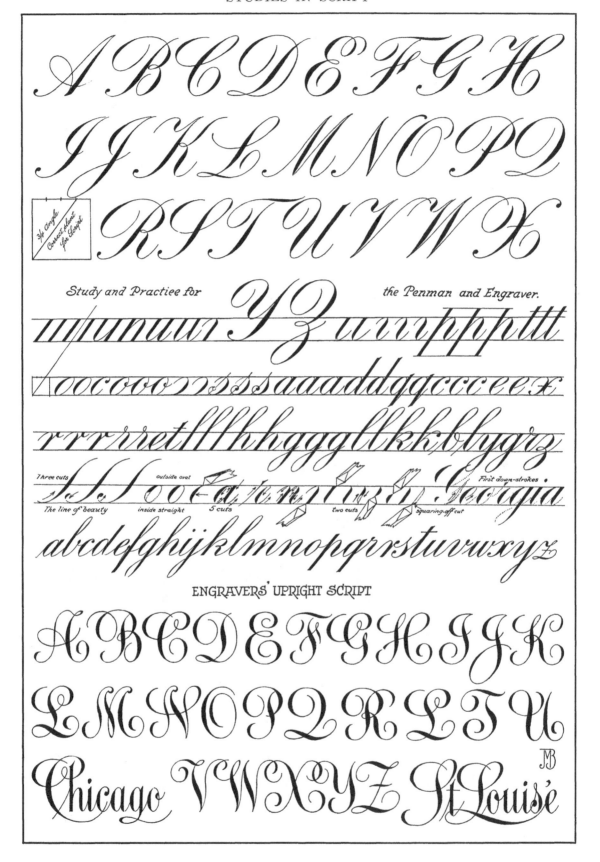

ABCDEFGH
IJKLMNOPQ
RSTUVWX

¾ Angle
Correct Slant
for Script

Study and Practice for YZ *the Penman and Engraver.*

Three cuts outside oval First down-strokes
The line of beauty inside straight 5 cuts two cuts squaring-off cut

abcdefghijklmnopqrrstuvwxyz

ENGRAVERS' UPRIGHT SCRIPT

ABCDEFGHIJK
LMNOPQRRTU
Chicago VWXYZ St Louise

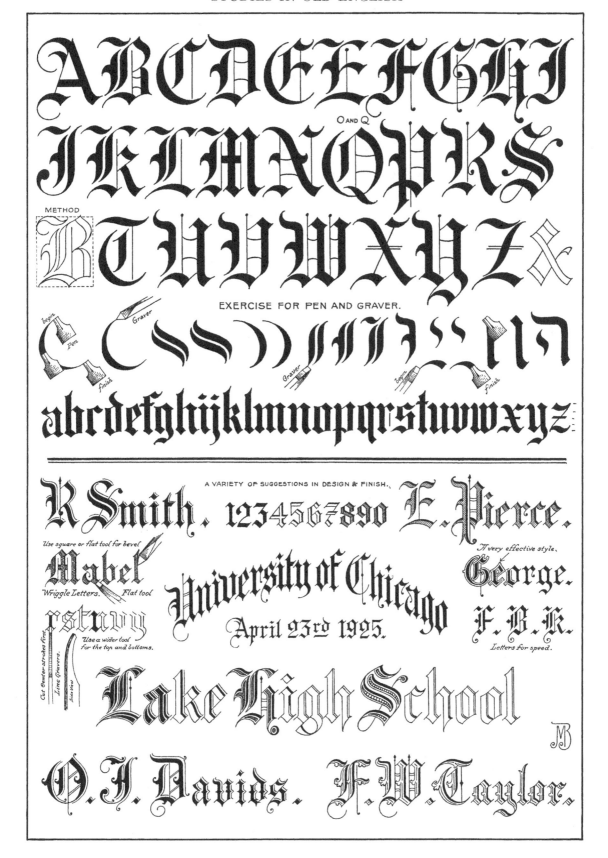

Artistic Diploma Filling

Samuel W. Pennypacker

1. Engrossing Hand

Henry R. Sanderson

2. German Round Hand.

William H. Richmond

3. German Text.

Charles B. Rodney

4. Old English, Not Retouched.

Robert K. Warwick

5. Old English Retouched.

Margaret W. Burnham

6. Old English, with relief line.

Engrossing Text, Word Practice

Adamson Brand Curtis Dent Easton

Faculty Graham Hunter Indian Kemp

Lamprey Meehan Norton Opp Painter

Queers Roberts Sinclair Tenney Uno

Venice Wylie Navier Young Zavierd

Whereas Resolved

By P. W. Costello, Engrosser, Scranton, Pa.

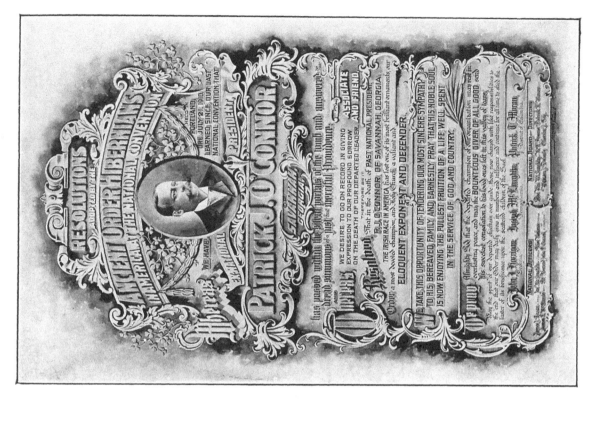

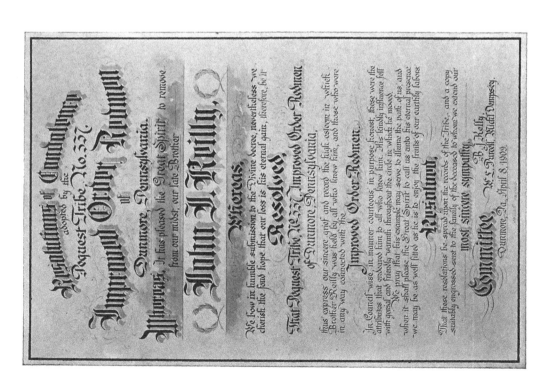

SPECIMEN ENGROSSING BY P. W. COSTELLO, SCRANTON, PA.

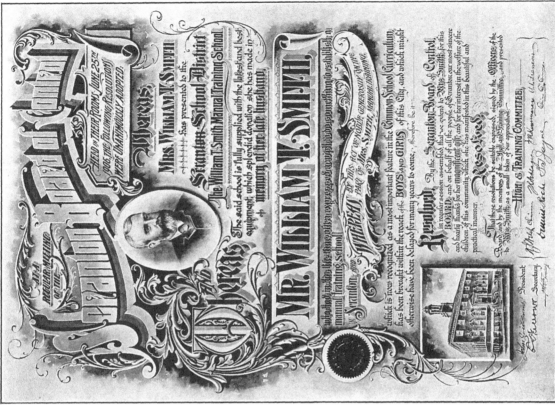

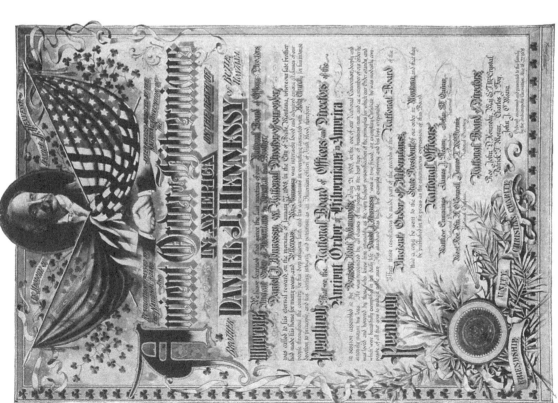

SPECIMEN ENGROSSING by P. W. Costello, Scranton, Pa.

37

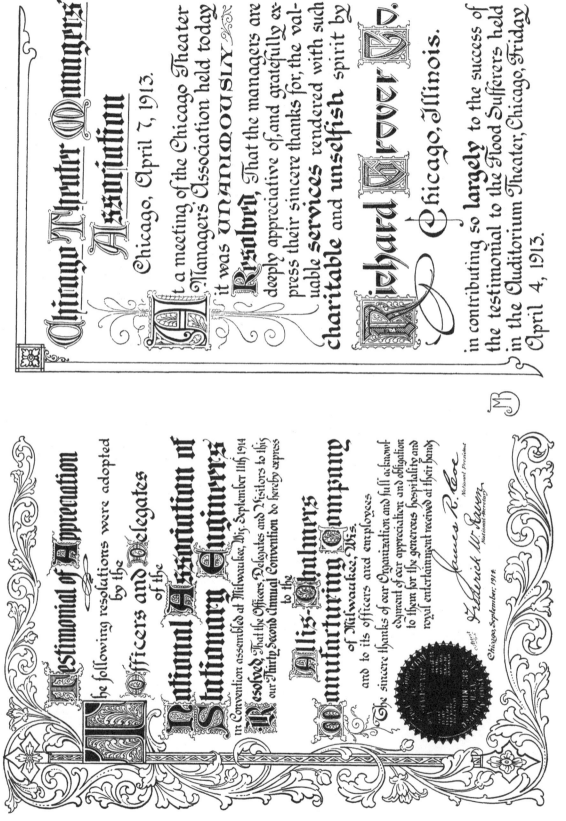

Chicago Theater Managers Association

Chicago, April 7, 1913.

At a meeting of the Chicago Theater Managers' Association held today it was UNANIMOUSLY Resolved, That the managers are deeply appreciative of, and gratefully express their sincere thanks for, the valuable services rendered with such charitable and unselfish spirit by

Richard Řrver D.

Chicago, Illinois.

in contributing so largely to the success of the testimonial to the Flood Sufferers held in the Auditorium Theater, Chicago, Friday April 4, 1913.

Testimonial of Appreciation

The following resolutions were adopted by the

Officers and Delegates of the

National Association of Stationary Engineers

in Convention assembled at Milwaukee, Wis. September 11th 1914

Resolved, That the Officers, Delegates and Visitors to this our Thirty Second Annual Convention do hereby express to the

Ellis-Chalmers Manufacturing Company

of Milwaukee, Wis.

and to its officers and employees

The sincere thanks of our Organization and full acknowledgment of our appreciation and obligation to them for the generous hospitality and royal entertainment received at their hand

James R. Cox
National President

Frederick W. Raven
National Secretary

Chicago, September, 1914.

38

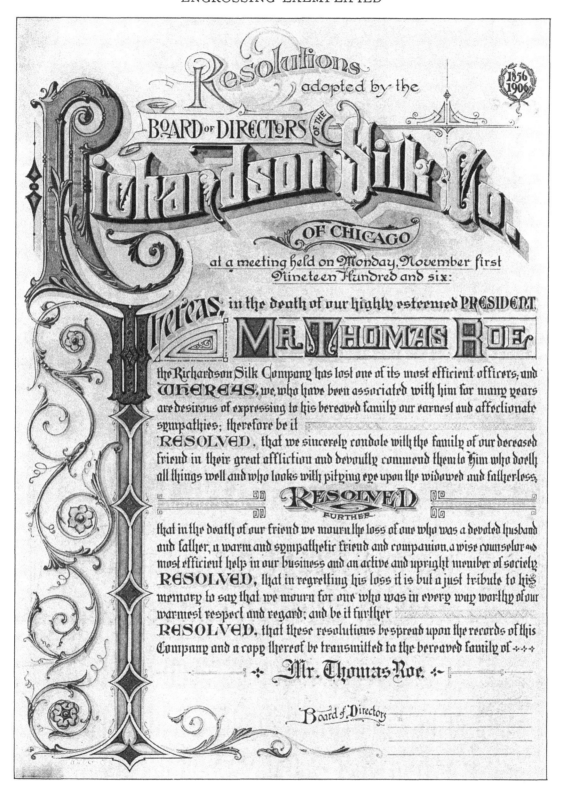

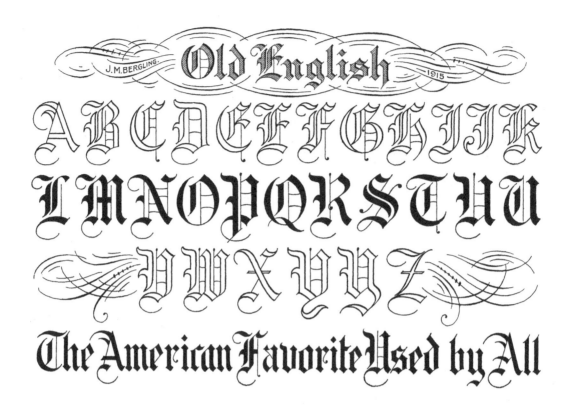

Old English

J.M.BERGLING · 1915

ABCDEFFGHIJK
LMNOPQRSTUU
VWXYYZ

The American Favorite Used by All

A Demonstration

Showing a few of the many forms the Old English can be used.

It is extensivly used for its semi-decorative appearance and can be condensed in a space such as few other alphabets will permit.

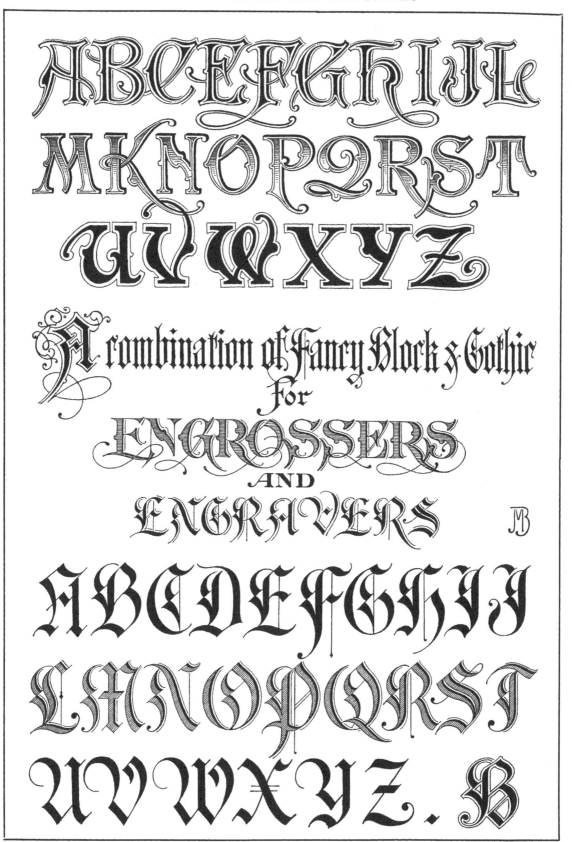

Presented to

WILLIAM ATKINSON

By his colleagues in Boston

ON HIS RETIREMENT FROM THE

Phœnix Insurance Company

and after 48 years service in insurance business

as a token of their friendship and regard

November 17 th 1915.

JMB

Presented to

John B. Watson

by his friends and admirers

on his retirement as president of the

Meadow Country Club

as a token of their esteem and appreciation

Chicago Oct. 5, 1914.

THERE are many interpret-
ations on MODERN ROMAN

THIS ILLUSTRATION

Will give a few ideas
of forms and styles that
have met with great favor,
Extensively used in News-
-paper & Catalogue work

by
Pen and Ink
ARTISTS

J. M. Bergling.

Coming to the

AUDITORIUM

In a Supreme
Artcraft Production Based
on the Play and Novel by
Eleanore Gates

"A POOR LITTLE RICH GIRL".

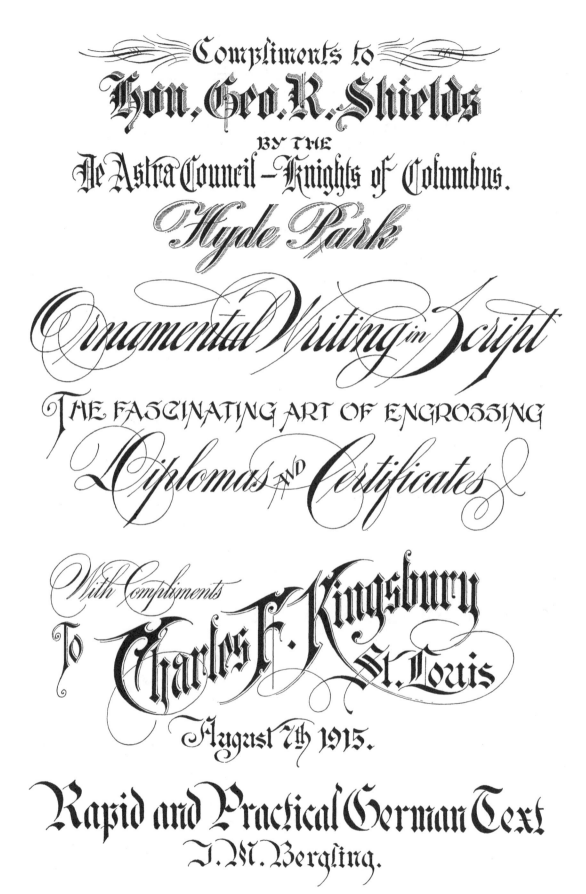

Compliments to
Hon. Geo. R. Shields
BY THE
De Astra Council — Knights of Columbus.
Hyde Park

Ornamental Writing in Script

THE FASCINATING ART OF ENGROSSING

Diplomas AND Certificates

With Compliments
To Charles F. Kingsbury
St. Louis

August 7th 1915.

Rapid and Practical German Text
I. M. Bergling.

The American Bond Script
An Other New Creation, Delightful and Pleasing
John M. Eustice.

Window Show Cards
Easy to make with Brush and Pen

The Script Artistique
McKay & Albright
Bar Harbor M.

One of the American Favorite
"RAPID POSTER ITALIC"

JB

MODERN FASHION DEMANDS
Attractive Ideas in Letters
Try this style on Your Stationery or with Brush

ABCDEFGHIJKLMNO
PRSTUVWYZ abcdefg
hijklmnopqrstuvwxyz . &

Crafty Lettering
for
**COMMERCIAL
ARTISTS**
An easy method for
doing these letters use
"Speed-ball" Pens
for the outline
and then fill in center.
by George Maurice.

A modern Classic,
a most beautiful type
for the
NEWSPAPER
and
MAGAZINE
ARTISTS
for headlines and
display cards.
by J.M.Bergling.

123456789
ABCDEFGHIJKLMN
OPRSTUVWXYZ &

The Graphic Arts

Much Study and Practice is Required

to become proficient in the

Art of Lettering

A Study in Easy
and
Artistic Alphabets
For Penwork
on
Show Cards, Poetry, Etc.

THIS SKELETON TYPE IS
most useful
where speed and delicacy
is required,
much in use by
ARCHITECTS, FOR MAPS
AND OTHER THINGS.

MODERN FRENCH ALPHA=

For Rapid Work This Is Practical &
AWAY FROM THE COMMON.

THE EUROPEAN WAR.

For Brush on Any Thing

San Francisco to New York

NATIONAL ASSOCIATION
OF ENGRAVERS AND DESIGNERS OF
AMERICA

The Artists' Club
ACADEMY DE ROYALE

Paris France

The National Society of
LITHOGRAPHERS & PRINTERS
CONVENTION 1917
London, England.

PIERCE ARROW
THE CAR DE LUXE
BUFFALO, N.Y.

Editorial

H·C·R

The Paris Shop
High Class Millinery

May best
Easter Wishes
be thine

H.C.RICE

THE BLACK CO
DETROIT, MICH.

Famous Publishers

by J.M.Bergling

49

Light Poster-Roman

IS A
GREAT FAVORITE AMONGST
ARTISTS AND SHOW-CARD WRITERS
DONE WITH A SINGLE STROKE
OF THE BRUSH OR PEN
AND BY VARYING THE
HIGHT AND WIDTH
OF LETTERS

A GREATER ARTISTIC
APPEARANCE
IS ACCOMPLICED.
THIS STYLE SHOULD APPEAL PARTICULARLY
TO THE
ART STUDENT AND AMATEUR PENMAN

Unique & Eccentrique Alphabets

ABCDEFGHIJKLMNO

PQRSTUVWXYZ.&.£.$.

Henry B. J. Wilson.

St Valentine

Say it with

Flowers

D B Marde Gras A C

abcdefghijklmnopqrstuvwxyz &

ABCDEFGHIJKLMNOP

QRSTUVWXYZ The Storm

BUILDING MACHINERY

CAMERAS SUPPLIES

ELECTRICAL SPECIALTIES. LAMP SHADES

Catalogue of Artistic FURNITURE 1918

NOVELTIES and Parisian JEWELRY

SPORTING GOODS a full line of Fishing Tackle

Jeffrey & Clark Crockery AND China

HENRY B. SMITH Importer of fine FURS AND SKINS

The Latest in SUMMER CLOTHING Nifty Foreign and Domestic Patterns

Diamonds & Pearls Theo. B. Stone Gold & Platinum Goods

REBAULT & CO STOCKS AND BONDS INTER OCEAN BLD'G, DETROIT.

John R. Stevenson SPECIAL ATTENTION GIVEN PHOTOS FOR PASSPORTS & HALFTONES STUDIO CHILDRENS AND CLUB SITTINGS CAREFULLY EXECUTED

STOCKS & BONDS

Gustav = Simpson

CHICAGO

EYE SPECIALIST

S. R. Brainbourg

345
STATE ST.
AND

ROBEY HOSPITAL

STATIONERY & BOOKS

C Bergh

Candies

Musical Instruments

Ferbault & Richard Co

LITHOGRAPHY & PRINTING

ABCDEFGHJKLMNOPQRST
abcdefg UVWXYZ hiklmnop
qrstuvwxyzß edpnr

ABCDEFGHJJKLMNOPQR
abcdef SCUDWFYZ· ghiklm
nopqrstßuvwryz·

ABCDEFGHJKLMNOPQRST
abcdefgh UVWXYZ ijklmnop
qrstuvwxyz·123456

ABCDEFGHIJKLMNOPQRST
abcdefghij UVWXYZ klmnopqr
stuvwxyz·123456789

54

Freehand Rapid Italic
Exemplified

"*Moon of Israel*"
by
Sir H. Rider Haggard

THE PARIS SHOP
"*Spring Opening*"
Fashion Show Days
Tuesday ~ Wednesday

SHOW-CARD ROMAN
Wholesale & Retail

ABCDEF
GHIJKLM
NOPQRW
STUVYY
abcdefghijkl
mnopqrstuw

UNIQUE ROMAN

ABCDEFGH
IJKLMNOPQR
STUVWXYZ
Illustrating a Series
of Variation in Letter-
Styles of one Alphabet
abcdefghijklmnopqrs
tuvwxyz.abgkufw

Unique Block

ABCDEFGHI
KJLPMRSNQ
QSTUVXWYZ
and
Half-Script Italics
"THE RED LADY"
A Fascinating New
Mystery Romance.

BRUSH AND PEN ARTISTS'

"HANDY IDEAS"

OF

LETTERING FOR ANY PURPOSE

embracing a variation helpful to form

a

CHARM and ATTRACTION

For

News Paper or Catalogue Work

OPERA
SEASON

Opens Feb, 1st

Advance sale of tickets
now going on

"CARUSO"
"Patricia"
"MARY GARDEN"

The
BOOK SHOP

complete stock
of the very best
books of great
Authors.

A few of the latest

"Cry of the weak"
by Eugene Pohle.

"A PRINCE THERE WAS"
by Ruth J. Albers.

"His only Love"
by Juliet Morton.

COLONIAL GARDENS

PARAMOUNT and ARTCRAFT
Motion Pixtures

Florence Arthnow

IN HER GREAT TRIUMPH

THE STAR & PALM BEACH

(From Lomis D. Alberti's famous book.)

BLACKSTONE
HARRY J. POWERS, MGR.

12th BIG WEEK
SEATS 2 WEEKS IN ADVANCE.

HELEN CULBERSON
IN

A TRIP ABROAD

A SENSATIONAL SUCCESS «««

Supported by
Famous All Star Co.

CENTRAL PARK
AL, JOHNSTON *Manager*
12th & Central Park Ave.

TO DAY ONLY
PARAMOUNT PRESENTS

ENID BERTHOW
in the heartthrobbing drama

THE LAW OF MEN

TO MORROW

WALTER KEARNS
IN
"THE BEST MAN"

Grand Spring Opening

FALL EXHIBIT

Mid-Summer Sale

Artistic
Novelties
in X'mas
and
New-Years
Greeting Cards.

CAFE
RIVIERA

Baby Lobster
AND
MILANO'S BAND

FALL FASHION SHOW

Gorgeous Fur Display

THE WORLD NOVELTY Co

UNIQUE AND ECCENTRIC LETTERS A splendid AND ATTRACTIVE TYPE

ART · BEAUTY · ELEGANCE

A WIDE RANGE OF OPPORTUNITIES FOR THE

AMATEUR AND PROFESSIONAL

A STUDY FOR

PLEASURE AND PROFIT

J·M·Bergling

THE COLVEGE HOP
AT THE HALL

TANGO AND THE OTHERS

GRAND SMOKER TONIGHT

Don't fail to show up

CONCERT

PROGRAM

THE FINE ARTS CLUB
IN CHICAGO JB

ART MUSIC
GRAND·OPERA
DRAMA

Beautiful Pearls of the Sea

Last Word in Paris Fashions

The Beverly Garden

Topsy Turvie all the rage

ABCDEFGHIJKLMN

OPQRSTUVWXYZ

HEAVY POSTER BLOCK
J.M.BERGLING

ABCDEFGHI

JKLMNOPR

STUVWXYZ

abcdefgijklm nopqrstuwy

SIGN PAINTERS FANCY
The "Art Nuvoe" of Roman

A B C D E F G H

I J K L M N O P

Q R S T U V W Y Z

Showing the rough pencil sketch

abcdefghijklmnopqrtuw

Ladies Tailor

A B C D E F G H R

K L M N O P Q S T U V

12345 WXYZ 67890

abcdefghijlmnopqrstuvwxyz

ABCDEFGHIJK

LMNOPRSTUW

The Glories of Ruth

Modern Art in Classic Roman

Artist & Commercial World

ARCHITECTS ALPHABETS.

ABCDEFGHIJKL
MNOPQRSTUVW
abcde X Y Z & & fghij
klmnopqrstuvwxyz

ABCDEFGHIKLM
NOPQRSTUVWXYZ

ABCDEFGHI
JKLMNQPSR
TUVWXYZ.&

J. M. BERGLING.

ABCDEFGHIJ
KLMNOPSRT
UVWXYZ.&

ABCDEFGH
IKLMNOPQ
RSTUWXYZ

A new and novel design
with a
GRECIAN TONE
very useful in a general way
for
ARTISTS, ENGRAVERS & ARCHITECTS

JB

abcdefghjklm
nopqrstuvwx
12345·z·67890

ABCDEFGHI
JKLMNOPQ
RSTUW XYZ

Strong and Graceful

ARTS AND CRAFTS

Plain, Artistic and so Different.
Just what you are looking for.

abcdefghiklmn
opqrstuvwxyz

GRAND POSTER DISPLAY

BY THE STUDENTS

ACADEMY OF ARTS

PARIS

ABCDEFGHN
KLMNQPSRT
UVWXYZ

JmBergling

LETTERS THAT CATCH THE EYE

ECCENTRIC AND GROTESQUE

ABCDEFG
HIJKLMN
OPQRSTU
VWXYZ&

J.M.BERGLING.

ABCDEFGHIJ
KLMNOPQR
STUVWXYZ

ATTRACTIVE
POSTER ALPHABET

ABCDEFGH
IJKLMNQPR
STUVWXYZ

NOVELTY DESIGN
FOR
7 TITLES, HEADLINES AND POSTERS
by J. M. BERGLING.

ABCDEFGH
IJKLMNQPR
STUVWXYZ

ABCDEF
GHIJKLM
NOPRST
UVWXYZ

J. M. BERGLING.

DARIO RESTA
The Demon of Speedway

ABCDEF
GHIJKLM
NOPQRS
TVWXYZ

CLASSIC ROMAN

ABCDEFGH
IKLMNQPO
RSTVXYZ

TWO STANDARD ADOPTIONS

ROMAN FROM THE FORVM

ABCDEFG
HIJKLMW
NQPRSTUV

MODERN ROMAN

ABCDEFG
HIJKLMN
OPQRSTU
VWXYZ&

FRENCH ROMAN

ABCDEFG
HIJKLMN
OPQRSTU
VWXYZ.&

JOHN B. STARK
Special agent for
THE CHICK AUTO

abcdefghijklm
nopqrstuvwxyz
123456789

ABCDEFG
HIJKLMN
OPQRSTU
V SIGNS Y

ABCDEFGHJ
KLMNOPQR
STUVWYXZ

ABCDEFGH
IJKLMNOPS
RTUVWXYZ

ARCHITECTURAL LETTERS
AND
SIGN PAINTERS FANCY

ECCENTRIC BLOCK.

ABCDEFGHI
JKLMNOPS
RTUVWXY&

ABCDEFGI
HJKLMNO
PRSTUVW
YOUR CHOICE
XYZ. &
ABCDEFGI
HJKLMNO
PRSTUVW

St. Patricks Day
Greetings

From the south to the north,
From the east to the west;
Here's to the green isle
That the Irish love best!
Yours
O'Brian

The powers of
the Opal.

October's child is born
for woe
And lifes wicissitudes
must know;
But lay an opal on
her breast
And hope will lull the
woes to rest.

Our lives —

should be like unto
the summer glows,
with promise and like
the Autumn rich with
Golden sheaves of works
and deeds ripened
on the field.

The place

that does contain my
Books, my best compa-
nions, is to me a glorious
Court where hourly I
hold converse with
Old Sages and
Philosophers.

JMB

WRITE your name with love, mercy and kindness on the hearts of those about you and you will never be forgotten

HE THAT CAN HAVE PATIENCE CAN HAVE WHAT HE WILL

FRANKLIN

THAT MAN IS IDLE WHO DOES LESS THAN HE CAN

The selection of appropriate Styles of Lettering for whatever purpose should be as important as the Artistic Treatment it may receive

John M. Bergling.

ABCDEFH
GIJKLMO
NPQRSTU

POSTER SCRIPT
A Quaint Design of Early
Spanish and French origin
John W. Davis. Lewy G. Burton.

ABCDEFGH
IJKLMNOP
QRSTUVWXY

A free-hand ROMAN for speed

ABCDEFGH
IKJLMNOPQ
RSTUVWYZ&

Rapid Brush Letters for

Show Cards.

ABCDEFGHI
JKLMNOPRS
TUVWXYZ

Method and Mediums for the Show Card Writer, With Pertinent Examples

By WILLIAM H. GORDON, Los Angeles,

One of America's foremost authorities on Lettering

Aside from the individual qualifications as a letterer the chief requisite of the show card writer is "Speed" and to this end, letter styles have been and are still being devised that can be made fast enough to accomplish the amount of work that the present day craftsman is called upon to complete in the average day's work.

If the show card man still copied the styles and methods of lettercrafters in producing hand lettering it would require the services of four or five workmen to accomplish in the same time that which is now done by one.

The evolution of reading characters (letters) is mainly responsible for the record breaking bursts of speed displayed by the show card man. Whereas most of our predecessors used carefully drawn or modeled "Upper case" or capital letters in most of all of their copy. We of today have by necessity devised certain styles of lower case or small letters that permit of greater speed in execution. These changes have occurred gradually, and for the most part their individuality in appearance is caused by the mediums employed in their production. For the major part of this work, certain styles of lettering brushes, pens and other materials have been devised which are specially adapted to the rapid semi-automatic rendering of the elementary principles envolved in these styles. These tools in turn have proven the logical possibilities of designing new letter styles or making acceptable modifications of existing styles, both of type and hand lettered origin.

The study of letter forms based on various classifications such as Printer's Gothic, Roman, Italic, Text and various others should receive careful attention by the student. The ability to distinguish these classifications in devising a style best adapted to certain needs is one of the prime requisites.

The ability to draw these characters does not qualify one as a letterer, especially from the show card writer's viewpoint, which is "Quantity first."

There are at least half a dozen methods of producing letters by hand, of these, but two can be considered; namely freehand modeled, and written.

Why the maker of show cards is called a show card writer, is from the fact that most of his lettering is really written, so called because it is produced by the single stroke method much the same as writing regardless of whether a bush or pen is used or the characters are slant or vertical.

A capable workman must be able to rapidly produce a fairly good resemblance to either upper or lower case Roman, Block, or so called Printer's Gothic, or Italics with numerals to match either case, by the single stroke method. Also he must be able to do this with either a brush or lettering pen, depending on the size of the space to be occupied by the copy. Lettering pens can be used with much greater facility than brushes, especially due to the fact that to successfully and rapidly manipulate a brush one must accustom himself to the absence of the feel of contact with the writing surface which is apparent in using a pen or other devices of a like character.

Further: the selection of brushes for this class of work requires intelligent consideration, likewise the preparation of the colors which must be of the proper covering quality, adhesive nature and of a consistency best calculated to hold the brush in proper chisel form while flowing freely therefrom.

There are various brands of ready-to-use show card colors now on the market, they are all good for the purpose intended. If something better is desired or a greater variety of colors needed, a selection of dry colors may be ground in water and the addition of sufficient gum arabic in solution, or ordinary mucilage added thereto will act as a binder, the addition of a few drops of glycerine to any water color or fresco colors will serve to keep them moist, prevent cracking and help the flowing qualities, the foregoing may require a little personal experiment to meet the desired results, but in the main this represents what is known as show card colors.

The brush question, outside of certain brands of so called one stroke show card brushes revolves itself into a question of individual requirements, each workman usually finds that better satisfaction can be obtained by choosing brands of manufacture that bear the approval of practical workmen. There are many kinds of brushes, simply made to sell, which usually find a quick resting place in the waste basket after a try out. Cheap brushes are the most expensive of all experimental purchases.

A selection of lettering pens for the smaller work is of vital issue. Those of the stub variety called round writing pens are generally known by trade names, and all have their particular use. Of these we have the Sonnecken and Hunt's No. 400 line of which there are eleven sizes, each particularly adapted to Text styles of lettering. Italic marking alphabets and single stroke Roman. These pens being flat chisel shape produce heavy down stroke of absolute even width, light or hair lines on lateral up strokes from left to right and on the horizontals, used the full width of the larger sizes it is impossible to condense the spacing and give the letters full weight values, but if sufficient space is available in which to make full round ovals and other oval elements, a beautiful copy can be made with these pens.

For pens that produce even width strokes throughout in the production of bold face display lettering there are two styles of the Speedball, round and square points, each fitted with fountain retainers, these may be used more successfully by the beginner or amateur than most other styles. It has been remarked that anyone who can letter with a pencil can operate these pens.

A new comer in the lettering field is the "Romitalic" so named for its performance or single stroke or modeled Roman and Italic letters, its advantages lie not alone in producing these most beautiful of all reading characters by the free hand single stroke method, but it works successfully on either smooth or rough surface papers, mat board, etc., using either ordinary lettering ink, or heavier than ordinary white ink or show card colors too heavy in pigment body to flow from other pens. It will also work in Japan colors on wood, tin, enamel or glass, being built on a flexible basis the gradation of accent runs from a hair line to one-eighth inch wide on the strokes, which allows either expansion in spacing or correct individual elements in the more condensed form, these pens also come in graded sizes.

Fig. 1 represents a rapid single stroke letter made with a N 7 Rigger brush. Size of original 8x12.

Fig. 2 a mixture of the elements of Text and Roman characters. Quick single stroke construction with No. 10 Rigger brush, suitable for semi decorative headlines, etc.

Figs. 3 and 4 with the speedball pens, size 6x8.

Figs. 5 and 6 display a characteristic Roman and Italic letter, single stroke, originals 7x10 in. with Romitalic pens.

Together with the specimens of show cards these examples were all prepared, not with a view of displaying faultless display of lettercraft or carefully drawn models, but to illustrate method and medium of production at a daily working speed required of the average show card writer.

To successfully acquire this ability one must first practice on and cultivate a freedom of arm movement, much the same as prescribed by teachers of penmanship, using the elements of lettering in place of the elements of penmanship but in the same degree of visual, sub conscious, arm and finger action. By visual we mean first; a fixed image of the subject in the mind's eye, which requires a well defined mental image of that which you attempt to produce. Therefore hap-hazard attempts or indiscriminate practice should be avoided. Always remembering the fact that a successful show card writer *writes* the *letters* and *does not draw them*.

WILLIAM H. GORDON.

Roman Variant
BRUSHABLE

abcdefghij

klmnopqrs

tuvwxyz &

ABCDEFGH
IJKLMNOPQ
RSTUVWXYZ

Single-stroke Construction

FIG 1

Mixed Roman Text -2-

abcdefghijklmz
nopqrstuvwxy
ABCDEFGHIJK
LMNOPQRSTU
VWXYVVWWV.

Roman and Italic Numerals $ 12.⁶⁵
1234567890 ⁰⁰
1234567890 75¢

FIG 2

abcdefghijk
lmnopqrstu
vwxyz & co.

ABCDEFG
HIJKLMN
OPQRSTU
VWXYZ&

FIG 3

abcdefghijklmnopqrs
··········tuvwxyz··········
abcdefghijklmnopqrstu
vwx condensed italic.yz

ABCDEFGHIJKL
MNOPQRSTUVW
XY ∻ UTILITY ∻ Z&

a bold face condensed,very
easy style to make and
adapted to rapid work

FIG 4

Rapid Single Stroke
Italics
Especially adapted for the
Show Card Writer

abcdefghijklmno
pqrstuvwxyz@2

ABCDEFGHI
IJKLMNOPQ
RSTUVWXYZ

Fig 6

Characteristic
single-stroke
ROMAN LETTER
for The
Show Card Writer

Who desires to impart
individuality of style
to his ordinary work.

abcdefghijkl
mnopqrstuv
wxyz vwxy &
A Combination
of Speed, Grace &
Legibility

Fig 5

January Clearance

One To Each Customer
ONLY
Gloria Umbrellas
$ 2.00

-fall

We cordially
invite you to view
this Exposition
of all that is
best and newest
in wearing
apparel for
F a l l

Women's Department
THIRD FLOOR.

The Best Value for the Least Money at Pollack's

Useful & Appropriate Holiday GIFTS for him or for HER"

ABCDEFGHIJKLM
NOPQRSTUVWXYZ
abcdefghijklmnop
qrstuvwxyz.

1234567890
ABCDEFGHIJKLM
NOPQRSTUVWXYZ
abcdefghijklmnopq
rstuvwxyz.!

ABCDEFGHIJK
LMNOPQRSTU
VWXYZ. abcdef
ghijklmnopqrstu
Four. vwxyz. Mode

ABCDEFGHIJKL
NOPQRSTUVWXYZ
abcdefghijklmnopqrstu
vwxyz. 1234567890.
Modern Brush Letters

A TRIP THROUGH CHINATOWN

THE BELL OF TOKYO

A

JAPANESE STENCIL TYPE

ABCDEFGHIJKLMS

ABCDEFGHIJK
LMNOPRSTUW

abcdefghijklmnopqrstuwy

HAI PING YONG Co.
Oriental fine Art Goods
Genuine Jades

"In the days of old"

An engraver at his bench
would sit
straining his brains
for a letter to fit.
But now how different, with
a book of this kind,
For every purpose a letter
he will find.

J. M. Bergling

Columbus and Santa Maria Y
"The Spiers Inn"

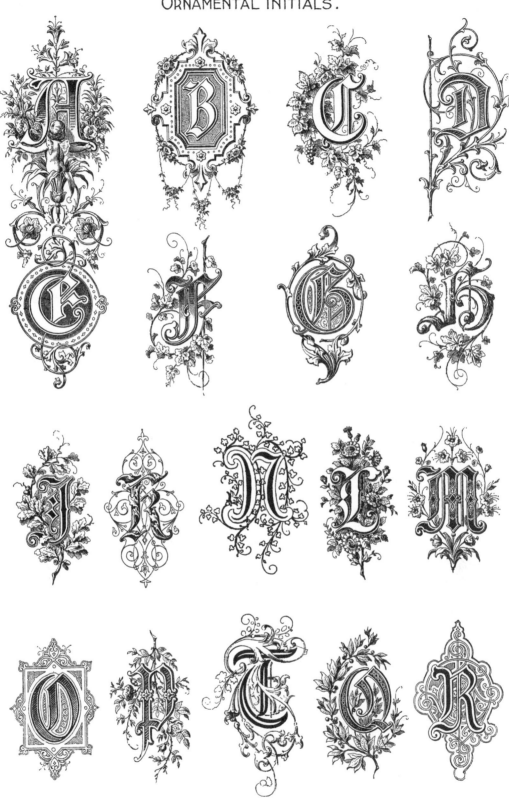

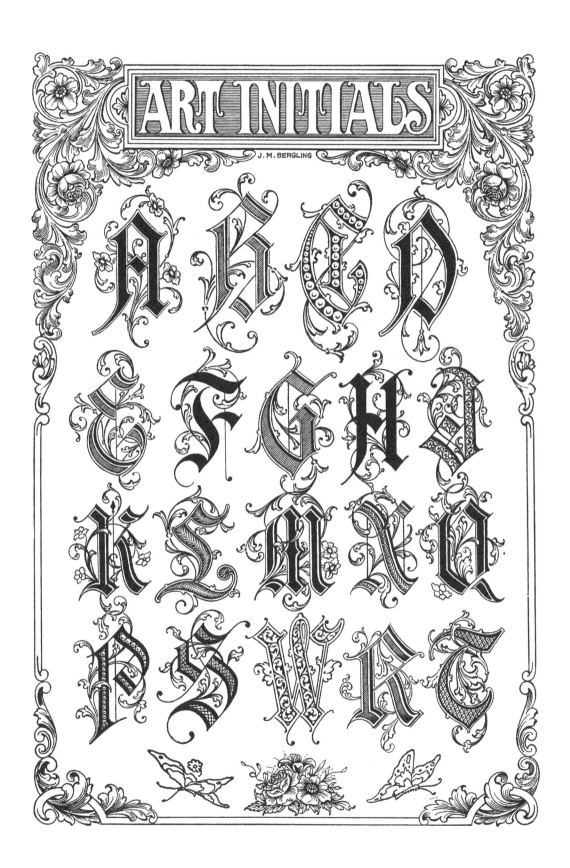

ART INITIALS

J. M. BERGLING

Stunts with Pen and Ink
and a little Artists White
For

NEWSPAPERS · MAGAZINES
AND CATALOGUES

Day by day
in every way
there is a
demand for
somthing new
and unique
in lettering

Birds
of
Paradise

JMB

There is no
limit to the
fascinating
study of new
CREATIONS
lettering
affords

THE HOUSE of FAMOUS MEN

The more you tell - the quicker you sell.

HUNGARIAN GOULASH

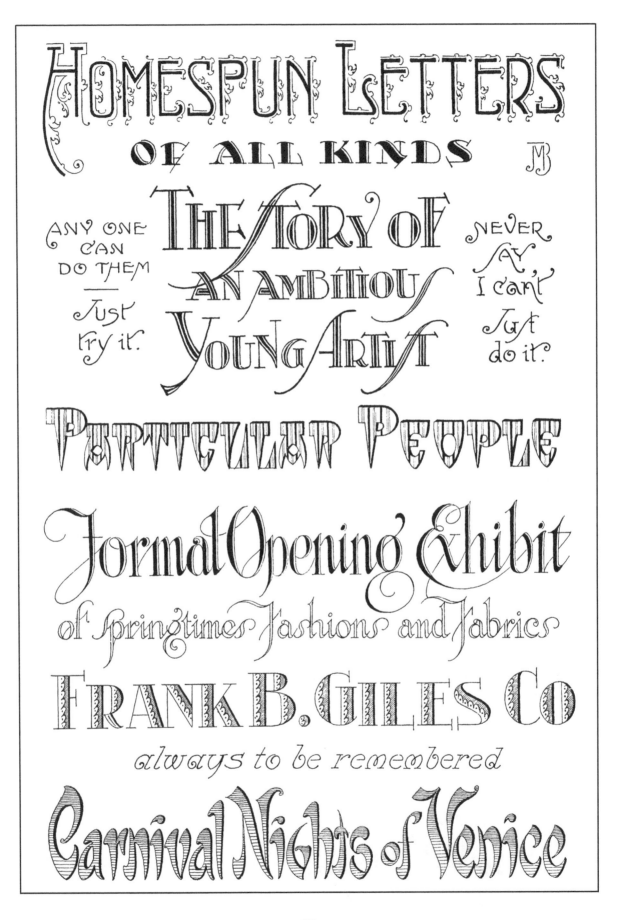

HOMESPUN LETTERS
OF ALL KINDS

ANY ONE CAN DO THEM — Just try it.

THE STORY OF AN AMBITIOUS YOUNG ARTIST

NEVER SAY, I can't Just do it.

PARTICULAR PEOPLE

Formal Opening Exhibit
of Springtime Fashions and Fabrics

FRANK B. GILES Co
always to be remembered

Carnival Nights of Venice

KING TUT-ANKH-AMEN

THE PHARAOH

of over three thousand years ago

CABARET GIRL

Bright and Snappy

MOULIN ROUGE

Worldlinsky's Famous Band

OPEN
DAY AND NIGHT

MB

TOPICS OF YEARS AGO

PRACTICE MAKES PERFECT

CUSTOM BUILT LETTERS

The Cartoonist's Dream

Laugh and be Merry

WIT AND HUMOR

On With the Dance

DANCE OF THE NYMPH

on the shores of the

Mystic Woodland

SAN FRANCISCO

STYLES IN GALORE

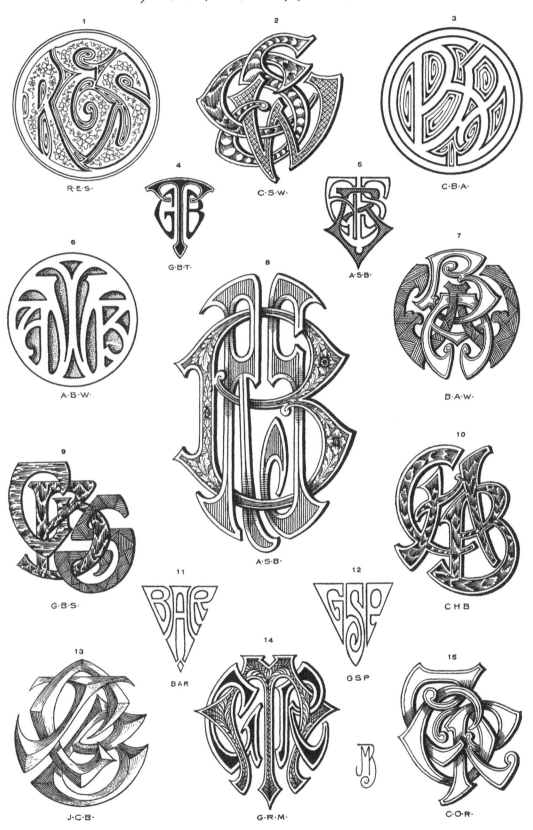

1 — R·E·S·

2 — C·S·W·

3 — C·B·A·

4 — G·B·T·

5 — A·S·B·

6 — A·B·W·

7 — B·A·W·

8 — A·S·B·

9 — G·B·S·

10 — CHB

11 — BAR

12 — GSP

13 — J·C·B·

14 — G·R·M·

15 — C·O·R·

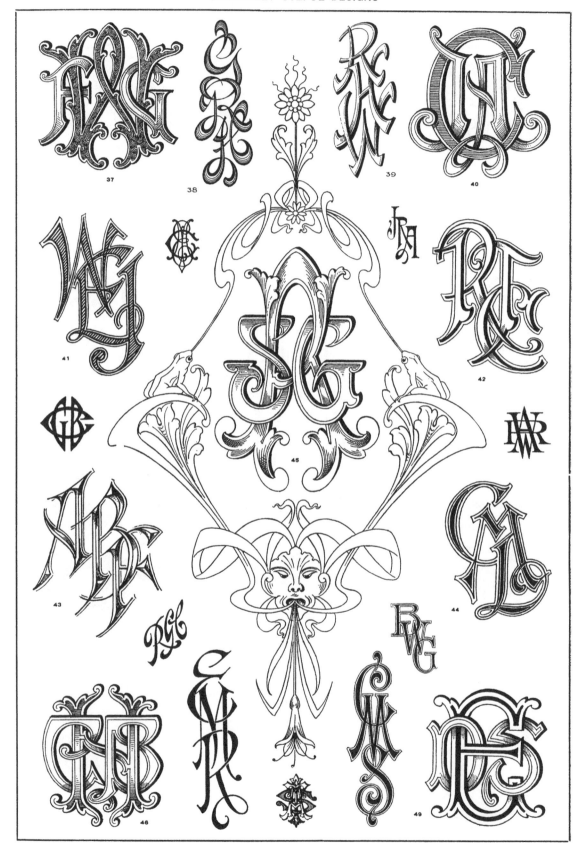

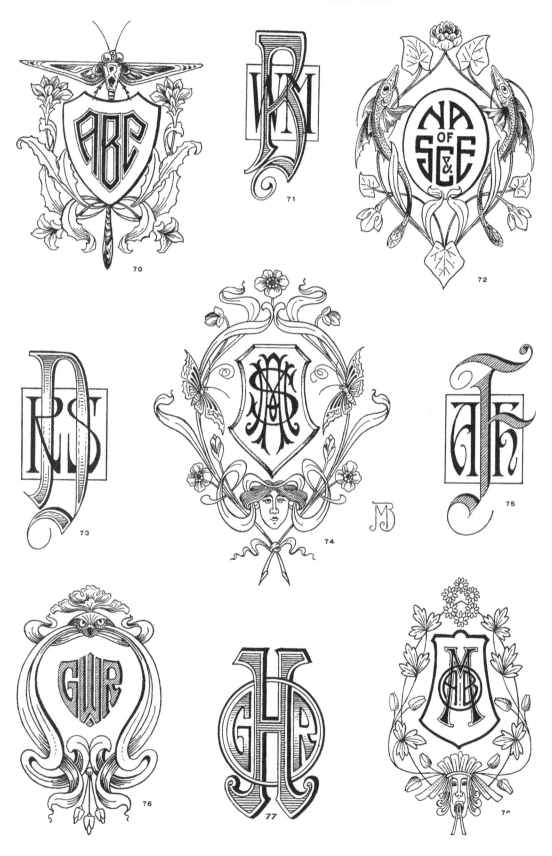

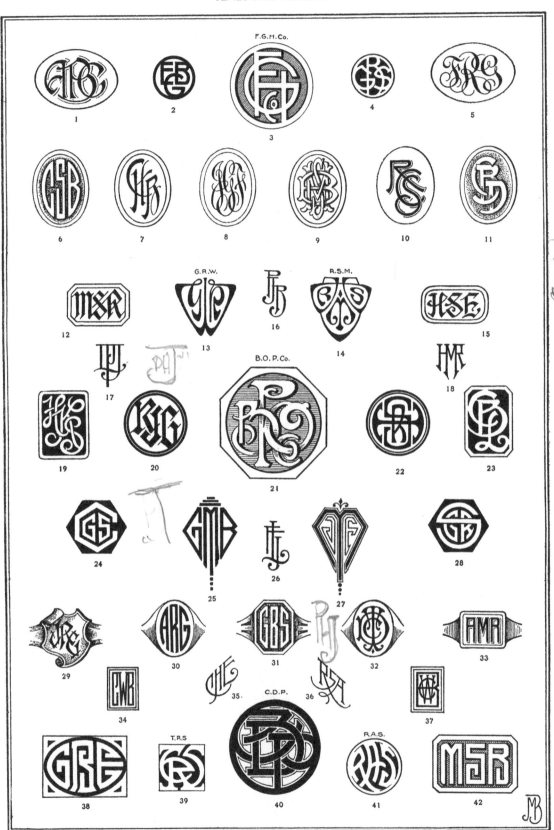

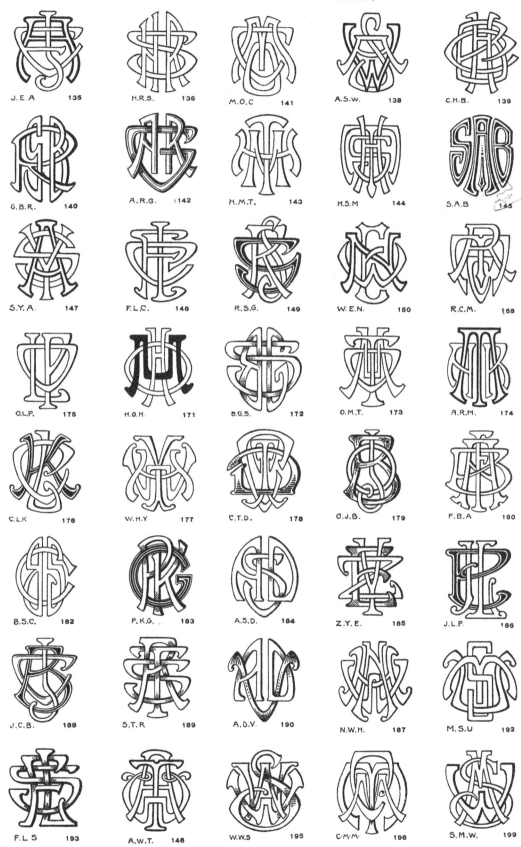

J.E.A 135 H.R.S. 136 M.O.C 141 A.S.W. 138 C.H.B. 139

G.B.R. 140 A.R.G. 1142 H.M.T. 143 H.S.M 144 S.A.B 145

S.Y.A. 147 F.L.C. 148 R.S.G. 149 W.E.N. 150 R.C.M. 168

O.L.P. 175 H.O.H. 171 B.G.S. 172 O.M.T. 173 A.R.M. 174

C.L.K 176 W.H.Y 177 C.T.D. 178 O.J.B. 179 F.B.A 180

B.S.C. 182 P.K.G. 183 A.S.D. 184 Z.Y.E. 185 J.L.P. 186

J.C.B. 188 S.T.R 189 A.D.V. 190 N.W.H. 187 M.S.U 192

F.L.S 193 A.W.T. 146 W.W.S 195 C.M.M. 196 S.M.W. 199

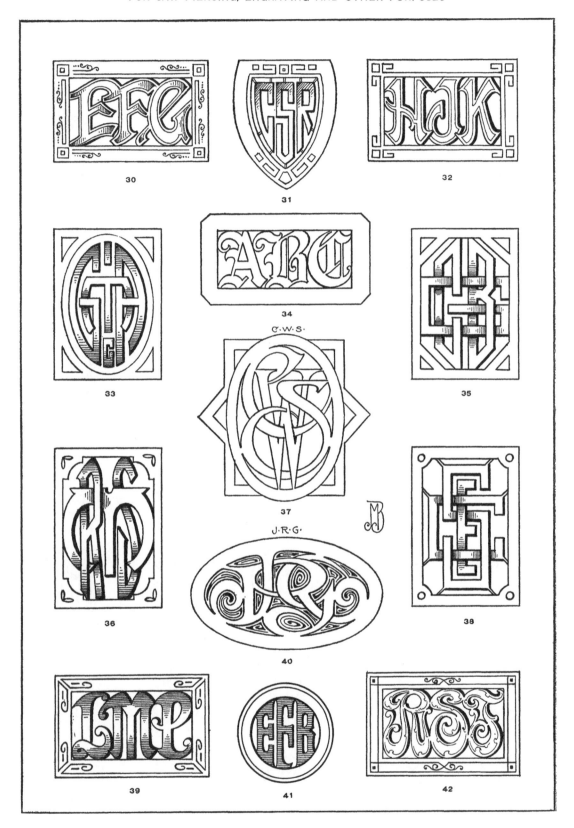

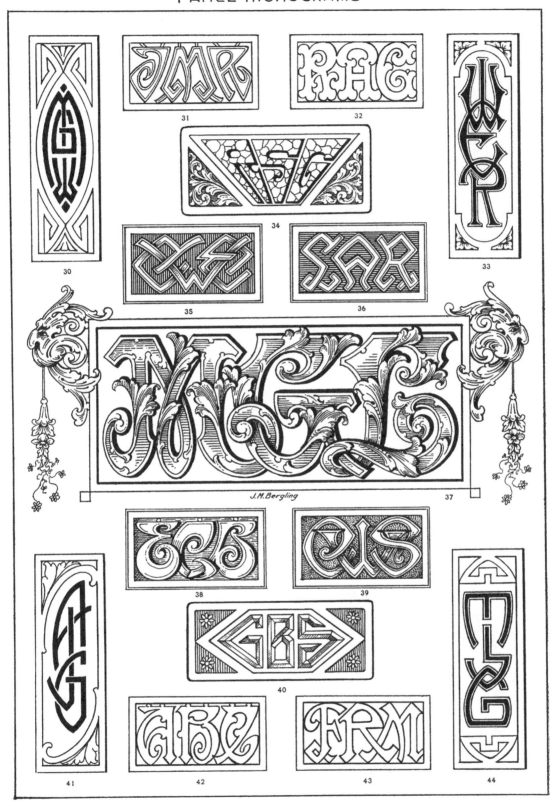

J.M.Bergling

Aug, New York Yacht Club 1916
Celebrated
International Cup Races

BOSTON COUNTRY CLUB
Robert E. Ward, Pres't.
Golf and Lawn Tennis

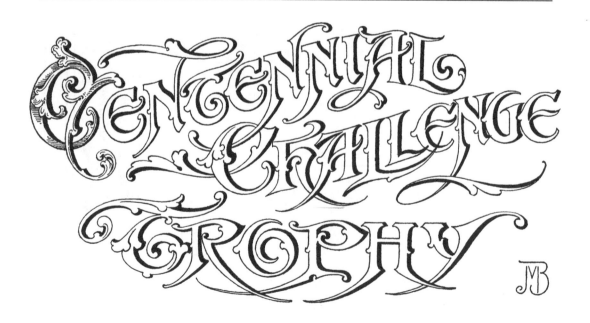

Centennial Challenge Trophy

KEY TO DRAWING OF MONOGRAMS

By using the system as indicated below the designing of monograms is greatly simplified. What you need is a Compass or Dividers, one end holding the lead, a Ruler and Pencils. Decide on what form wanted, proceed to make the diagram and then block out your letters. First attempt may be discouraging, but keep on trying and you will be delighted with your experiment and final results. J. M. B.

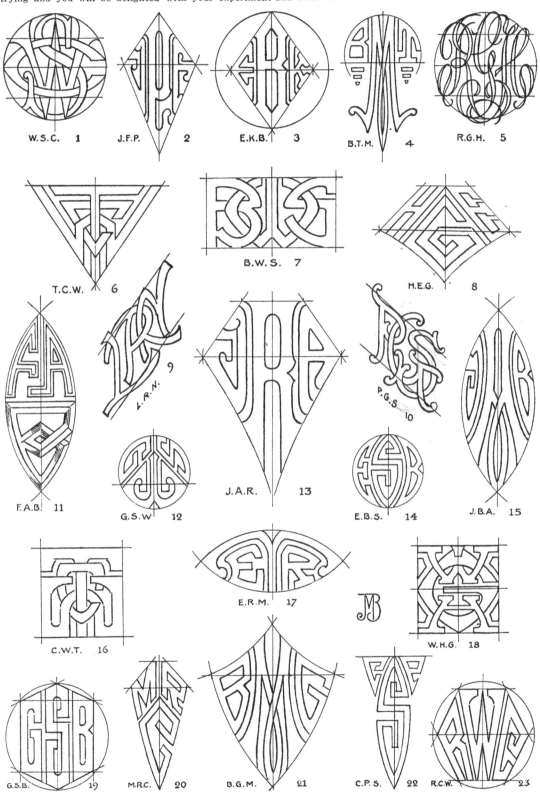

W.S.C. 1 J.F.P. 2 E.K.B. 3 B.T.M. 4 R.G.H. 5

T.C.W. 6 B.W.S. 7 H.E.G. 8

L.R.N. 9 P.G.S. 10

F.A.B. 11 G.S.W 12 J.A.R. 13 E.B.S. 14 J.B.A. 15

C.W.T. 16 E.R.M. 17 W.H.G. 18

G.S.B. 19 M.R.C. 20 B.G.M. 21 C.P.S. 22 R.C.W. 23

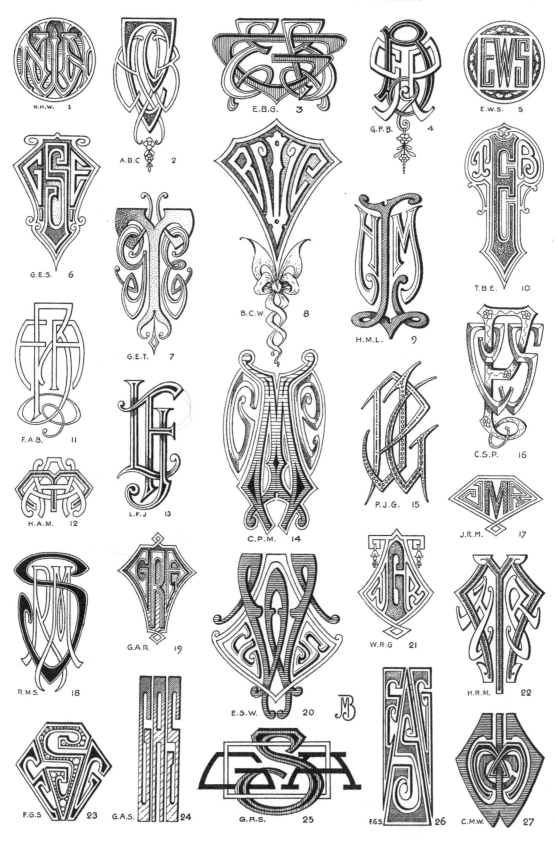

N.H.W. 1

A.B.C 2

E.B.G. 3

G.P.B. 4

E.W.S. 5

G.E.S. 6

G.E.T. 7

B.C.W. 8

H.M.L. 9

T.B.E. 10

F.A.B. 11

L.F.J 13

C.P.M. 14

P.J.G. 15

C.S.P. 16

H.A.M. 12

J.R.M. 17

R.M.S. 18

G.A.R. 19

E.S.W. 20

W.R.G 21

H.R.M. 22

F.G.S 23

G.A.S. 24

G.A.S. 25

F.G.S 26

C.M.W. 27

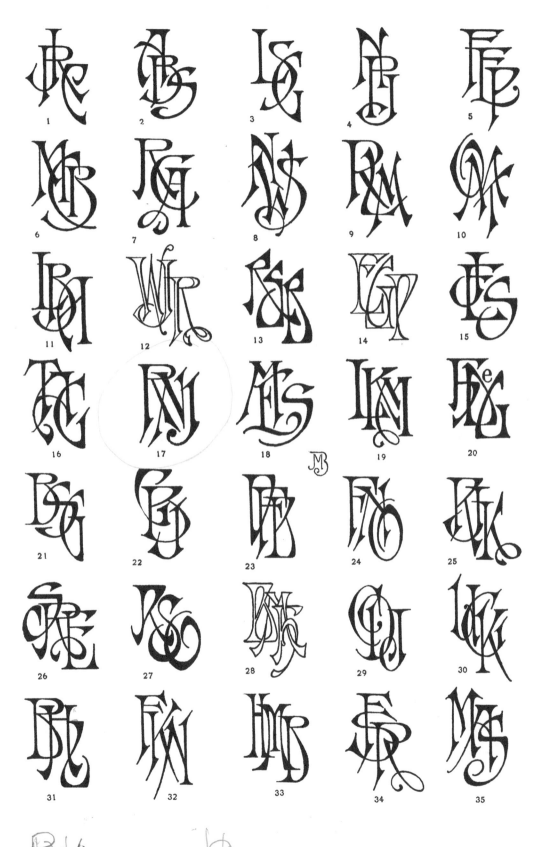

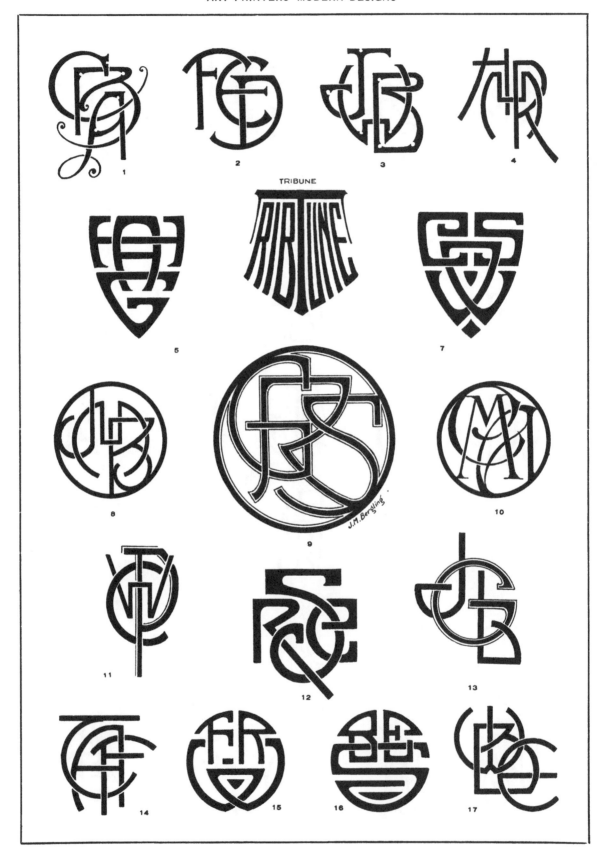

C.W.S.　　1.

George E.B.　　2

Robert M.S　　3

R.C.S　　4

George B.Gunkel.

Patterson.

M.R.Brown.

F.C.W.　　12

The Chicago Examiner.

E.F.N.　　15

J.E.Foster　　13

H.M.Wilson　　14

MAXWELL.

113

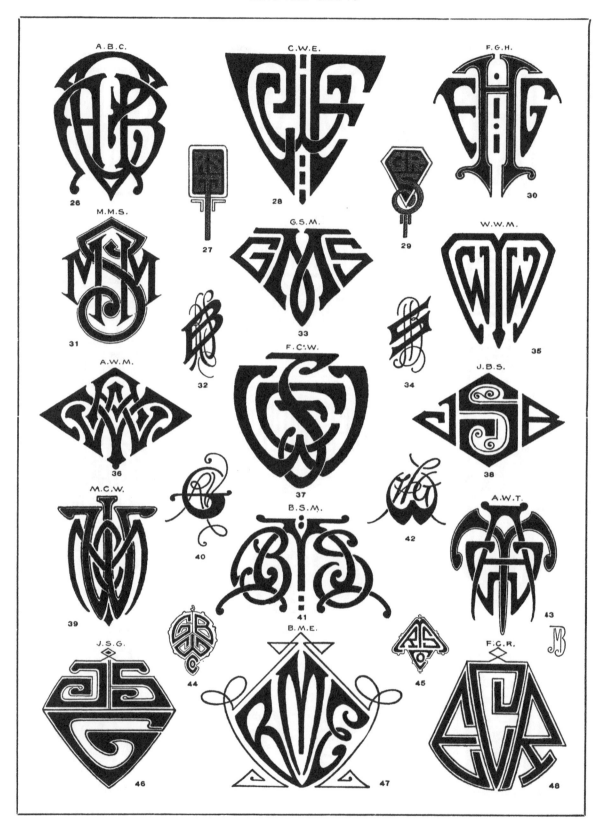

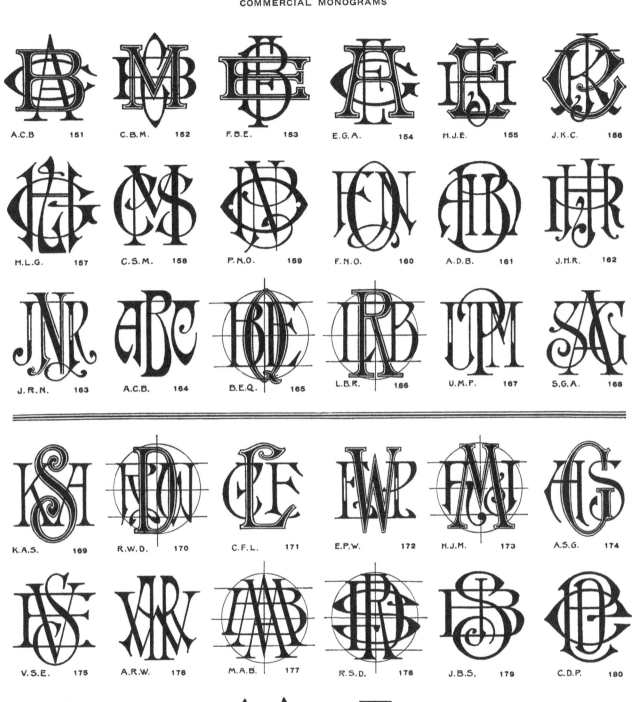

A.C.B 151 C.B.M. 152 F.B.E. 153 E.G.A. 154 H.J.E. 155 J.K.C. 156

H.L.G. 157 C.S.M. 158 P.N.O. 159 F.N.O. 160 A.D.B. 161 J.H.R. 162

J.R.N. 163 A.C.B. 164 B.E.Q. 165 L.B.R. 166 U.M.P. 167 S.G.A. 168

K.A.S. 169 R.W.D. 170 C.F.L. 171 E.P.W. 172 H.J.M. 173 A.S.G. 174

V.S.E. 175 A.R.W. 176 M.A.B. 177 R.S.D. 178 J.B.S. 179 C.D.P. 180

M.M.M. 181 O.M.K. 182 U.B.W. 183 A.F.B 184 G.B.T. 185 N.E.W. 186

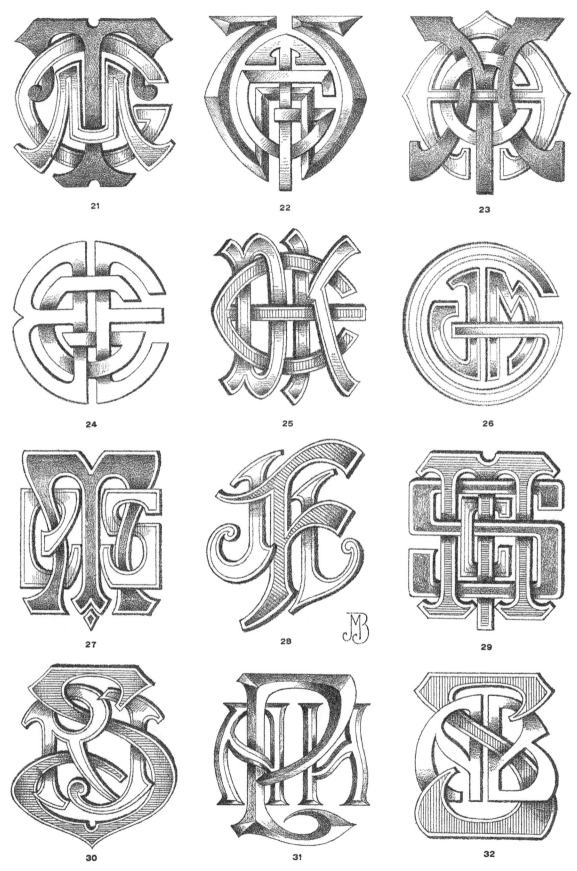

21

22

23

24

25

26

27

28

29

30

31

32

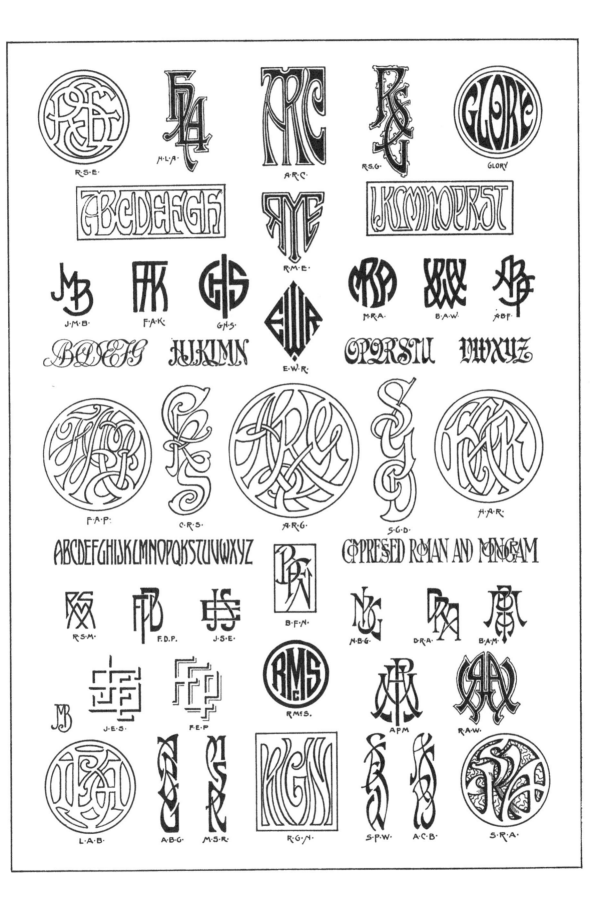

J. M. Bergling and his daughter Mildred